PRAIRIE
LIGHT

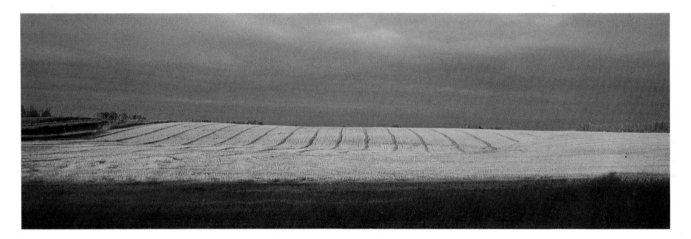

To my mother, who introduced me
to the world of prairie light,
and to my father, who taught me
how to survive in it.

PRAIRIE LIGHT

COURTNEY MILNE

FIFTH HOUSE PUBLISHERS
Saskatoon, Saskatchewan,

First published 1985 by Western Producer Prairie Books

Cover photographs by Courtney Milne
Cover and book design by McKay Goettler Design

The publisher gratefully acknowledges the support received from The Canada Council and the Saskatchewan Arts Board

Printed and bound in Canada
92 93 94 95 96 5 4 3 2 1

Canadian Cataloguing in Publication Data

Milne, Courtney, 1943–

Prairie light

First published 1985 by Western Producer Prairie Books
ISBN 1–895618–07–X (bound)—1–895618–11–8 (pbk.)

1. Landscape photography - Prairie Provinces.
2. Prairie Provinces - Pictorial works. 3. Milne,
Courtney, 1943– I. Title

FC3234.2.M54 1992 779'.36'092 C92–098162–3
F1060.M54 1992

FIFTH HOUSE PUBLISHERS
Saskatoon, Saskatchewan
S7K 0R1

CONTENTS

TECHNICAL NOTES

For those with a special interest in capturing the prairie landscape on film, each photograph in this collection is accompanied by a brief description of the film, the lens, and exposure setting. In the case of a zoom lens, I state the focal length used as closely as I can determine. Filters are also mentioned when employed. For almost every photograph I have used a tripod with a ball-and-socket head. The tripod assures me of careful and precise framing as well as camera stability at any shutter speed while the ball-and-socket head makes manipulating the camera extremely quick and efficient. All the photographs were made with a 35mm camera. My cropping is done in the viewfinder except when I chose to crop one edge in order to alter the proportion of length and height.

I take most of my meter readings with my camera meter. Occasionally, I use a spot meter to measure the light reflected from small areas in the scene. Often I take the exposure reading from a selected area of the scene, decide how light or dark to render that area, and vary the exposure accordingly. I have mentioned the specific area used for each picture in which I employed this technique. As an example, for *Sunrise Sunset* on page 7, "exposure for sky opening" means I took the meter reading directly from the bright opening in the sky and used that exposure for the overall scene, in order to produce good color in the highlights and render the clouds extremely dark. I make all my exposures manually so that I have total control of aperture size, shutter speed, and amount of exposure. It is important to interpret exposure settings according to film type. Kodachrome, for instance, displays less latitude in its tonal range than Ektachrome, and therefore tolerates less underexposure. High speed Ektachromes can be underexposed up to three or four f-stops and still portray some color and detail.

The following abbreviations appear in my technical descriptions:

Ek — Ektachrome
K — Kodachrome

The number following the film type is an index of how sensitive the film is to light. An index of 64 or 100 is medium, 200 or 400 is fast, while 25 is slow. The slower the film, the more light is needed to make a normal exposure.

mm — millimeters refers to the focal length of the lens used.

exp — exposure reading, while the number preceding it (such as -1 exp) refers to the deviation in f-stops from the normal reading.

These descriptions have been included only for the benefit of the reader interested in camera technique.

ACKNOWLEDGMENTS

Prairie Light was initially an exhibition of thirty of my landscape photographs, organized and circulated by the Mendel Art Gallery in Saskatoon.

Teaching is an excellent way to learn. I would like to thank my photography students, from whom I have learned a great deal. I owe a large debt of gratitude to Freeman Patterson for his teaching, support, and encouragement. In 1978 his week-long photography workshop was the beginning for me of a more intensive involvement with my subject matter. Freeman helped me to see the extraordinary in the world around me. More recently, I spent several days with Ernst Haas, and was inspired by the rich symbolism in his photography. He has given me new goals for which to strive.

I have also been influenced by painting, particularly the work of several local artists: Lorna Russell, Clint Hunker, Doug Thiell, and Mary Weiler. Lorna's dedication to her art has been a model for me and our trips together on the prairie have always been a rich source of seeing and sharing. Art books on Tom Thomson, Emily Carr, A. Y. Jackson, A. J. Casson, and Robert Bateman continue to give me joy and expand my vision.

When I take a nostalgic look back over the past decade, my heart goes out to the many people who encouraged me to take the leap of faith. Loreen Wilsdon, Don and Nettie Carr, Tana Dineen, Jo Claire, Cory Wiss, Karen Bolstad, my sister Bonnie Nygren, Dan and Joanne Sydiaha, Solinus and Mahara Jolliffe, and Dave and JoAnne Goodrick are a few of those who were my support group in the early days. Thanks to Nancy Fleming, Beatrice Magee, Louise Kozroski, Lorrie Sullivan, Dan Rayner, and Bob Stevenson for showing me their places on the prairie. A special thanks to Louise for her poem "Coming Back." I am most grateful to Michael and Jean Shaw whose Wakaw Lake cabin I occupied during many of my outings.

To complete the photography for this book took over ten years; the writing was six months of joy. Loreen's frequent reminder, "When are you doing your prairie book?" was my main impetus to get working on it. Thank you to Isobel Findlay for the fine editing job and Susan Kargut for her constructive comments and creative input. Thanks also to Peggy Finsten, Colette Horne and Terry Harley for typing the manuscript and its revisions.

Fred Chapman helped with the initial choice of photographs and Cam Merkle printed the color work prints from my slides. Po Cheng, who cleaned and repaired my camera equipment more times than I care to count, also deserves a hearty thank you. I appreciate the support of Bruce Dahleger of United Graphic Services, who took the unprecedented step of inviting me to supervise the production of the color separations for this book.

Like the prairie, I too have experienced some lean years in the course of this project. A heartfelt thanks to Fred Mulder for the generous financial assistance when it was most needed. Thank you also to Graeme Card for the inspiration I have received from his album, *Dorothea's Dream*, and for permission to quote from two of his songs in this book.

Above all, I would like to express my appreciation to Patricia Joudry, that great prairie soul who gave me the courage to reach beyond my grasp.

INTRODUCTION

The prairie landscape is, for me, a visual feast that continues to bring joy as well as scope for expression. But it was not always that way. As a child I loathed the harsh winters, but gained a healthy respect for the elements. It was on my daily treks to school that I learned to judge how far I could go without freezing my flesh.

I soon discovered how to take my thoughts and attention away to far-off places. I would conjure up images of sandy beaches, blue skies, and lush, green meadows, just like the exotic pictures I had seen in *National Geographic Magazine*. California loomed as my all-time favorite place. After all, it had everything: beaches AND Disneyland AND the San Diego Zoo, and best of all, WARM WINTERS! Why couldn't Dad sell dune buggies or surf boards instead of bale stackers and double-swath attachments?

Nor was it just winters. The landscape too seemed boring. Even in summer, it appeared dull and colorless compared to the utopian hills that Dick and Jane romped over in our first-grade readers.

Although I had little use for the prairie, I did develop a great love of the outdoors. Camping was a special treat. Just finding a stand of trees large enough to provide shade was reward enough, but to get a spot beside a creek that really flowed was paradise! As long as the wheat fields were out of sight, I could believe I was anywhere. The ultimate sensual experience was to go swimming beneath a midnight sky ablaze with northern lights! Even the black womblike water seemed to take on a special glow.

But these idyllic moments were all too fleeting. There were constant reminders as farm trucks and tractors roared by that the grid road was just beyond the trees, that we were just on the prairie. There was none of the exotic splendor of my dreams in this flat, familiar setting.

My only childhood memory of vivid prairie color is watching sunsets. I remember the deep crimson that would linger long after sundown. Yet even the sunset was tainted with the unhappy acknowledgment that I had to go in and get my homework finished.

I remained on the prairie until I finished university. My first move thereafter was to the land of my childhood dreams, California. It was only then that I realized just how special were the prairie sunsets. My evenings felt lonely and incomplete when the sun dropped out of sight and the sky turned black. The darkness, the continual traffic noise, and the police sirens were poor substitutes for the evening light of home.

Nor had I ever appreciated the fresh, clean air that blessed the prairie landscape most of the time. The smelly, smoggy haze that so often hung over greater Los Angeles was a continual source of comparison. Soon after I finished graduate

school I left California, but I did not return to the prairie. Job opportunities and further schooling led me to Guelph, Ontario, and to Minneapolis.

In total, I was away from the prairie landscape for about nine years. I can't say that I missed it because rural Ontario and Minnesota each has its own charms. I was surprised, however, that in neither place did the temperature have to dip so low as out west for me to feel chilled. The cold, moist air could be numbing, especially when the wind blew. Nor did people prepare themselves for harsh weather. The prairie has a history of severe winters and unpredictable climate. We have learned to expect the worst, to recognize that our success is tied to the land, and our destiny to the elements.

When I returned to the prairie the landscape looked more attractive to me than I remembered. I welcomed the wide open spaces and the sense of freedom endorsed by the infinite prairie skies. I liked the unpredictability and the excitement of the storms. I felt drawn by the vibrancy and sensuality of the prairie color, and to the distinctiveness of the seasons. No more struggle to remember what month it was; I had only to glance out the window and see the date written on the land or in the trees, or announced by the song of a meadowlark. Prairie light seemed to range across the complete spectrum of human emotion. Identifying with its variety of moods enlarged and enriched my vision.

To my surprise and delight I found that my new lease on the prairie was also shared by others. As I began to exhibit my photography, people expressed to me what this land meant to them. They talked of the space, the openness, and the freedom to live and breathe. I discovered that others had also been seduced by more alluring places, yet felt drawn to return home. Louise Kozroski presents our dilemma in sonnet form. With passion and conviction she speaks to the land that gives us identity and strength, the place where we belong:

Coming Back

My wandering eye has slid down B.C.'s form
and drunk in green delight along her edge.
She beckons me with breath so moist and warm,
with stately limb and flower-laden ledge.
Wood takes me in; Virginia pirouettes,
Rose flaunts her beauty shamelessly;
and Holly, Fern and Ivy — all coquettes!
At sea, the lolling sailboats wink at me.
I contemplate unfaithfulness. Your face,
so broad and honest, swims before my eyes.
I need your open fields, I need your space,
the challenge on the wind, the endless skies.
With sweet regret, I come to you again;
my roots are in your soil beloved plain.

The prairie is *not* the kind of place that reaches out and plucks at your romantic

heart strings, as do the Rocky Mountains or the sea. The prairie is quiet, gentle, and unassuming, with only fleeting moments of passion and drama. But its dominant moodiness makes the times of vibrant color all the more exquisite! Now I am amused by people who tell me they find the prairie drab and colorless. Granted the prairie can look monotonous if all you do is drive through it at a hundred kilometers an hour. You need to spend time on the prairie to appreciate the many facets of its personality. Even then, you must take time to look and experience its subtle shifts in temperament. Dull, overcast days offer the best conditions to observe the landscape close-up, yet these are the very occasions when we are least likely to give this land its due. When the tones are even, devoid of bright highlights, or distracting shadows, we can better appreciate the subtle nuances of color.

The pictures in this collection are about the elements: the seasons, the weather, the sun and wind, and how they affect the land and our lives. If the farmers do well, we all share in their prosperity; if they don't, many of us feel the blow. But the elements can also affect us directly, even if we do not depend on them for a living.

The prairie is a land of extremes, an immense land that touches all who inhabit it. Neither city nor town offers sanctuary from nature's dominion. Prairie skies put human architecture in its place; prairie storms recognize no boundaries. I have always paid those storms special respect; I find myself walking into the heart of them, camera in hand, as if to probe their weaknesses or know their strength. Maybe, facing them head-on, attempting to wrest from them a portion of their beauty, is somehow to dispel a measure of their menace.

My pictures are an attempt to unveil the magical moments of the prairie day—from the joyous greeting of the dawn to the stark intensity of midday. Then the light grows warmer as the enriched rays of early evening dissolve into the unmatched splendor of the prairie sunset. Like a bugle call it warns us that the finish is at hand and summons its legions of light to retreat before the impending forces of darkness. In this ever-changing light the prairie landscape can conjure images of past, present, and future, of the cycles of decay and renewal, or can make another world of otherwise familiar terrain.

The immensity of the prairie can overwhelm with a sense of man's insignificance or offer a profound sense of contentment and peace or exhilarate with a vision of nature's potency and a grander scheme of things. Whatever the response the prairie will not be ignored. Photography is for me the added reason for being out there enjoying it, as well as a way of sharing it with others.

Welcome to the magic of prairie light!

3

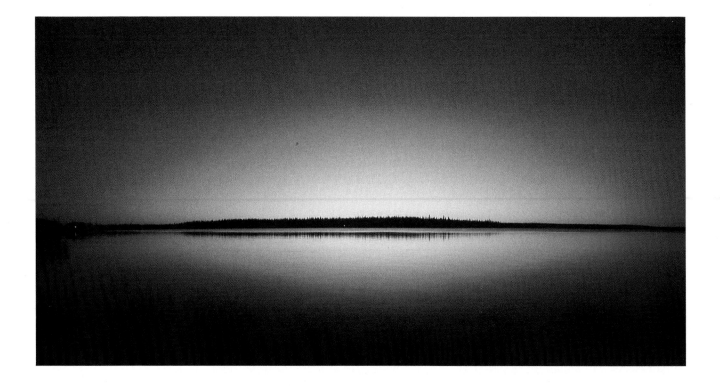

THE RISING SUN

Because morning represents the unfolding of a new day, I like to make pictures that convey that feeling. In the photograph opposite, the predawn light encompasses the entire eastern sky. Using a fisheye, an extremely wide-angle lens, I was able to include the night blackness and the new light. Seeing both has the feeling for me of the early morning light pushing away the darkness and heralding the beginning of a new day.

The marriage of morning and spring can intensify the sense of vitality and rebirth, bringing out those aspects of light and landscape that best symbolize the morning. There are several features of morning light, including the angle of light, that lend themselves to photography. When the sun is low in the sky it casts long shadows that can add to the design of a picture. As well, a play of light and shadow helps to add realism and sharpness to a picture by revealing texture. An ideal angle for such effects is at right angles to the sun, as in *Six A.M.* on page 14. Early morning sunlight is also warm and vibrant. Paradoxically its warmest red occurs before dawn, when the air feels the coldest.

In morning sunlight I like to keep an eye out for backlit foliage. The colors of leaves, flower petals, reeds, and grasses become most saturated by viewing them into the sun. When the exposure is made for their bright translucent tones, the color film records the background shadows as black. The two photographs on pages 16 and 17 display the most vibrant of prairie color.

Atmosphere is another bonus for the early morning photographer. Mist rising from the lake and dew on reeds and grasses are a joy to witness but they don't last long. Even when the sun is not shining, close-up photography and landscapes without sky showing are often moodiest in the morning. But unlike most other geographical areas, the prairie landscape often records best in direct sunlight. The first two hours of light are most likely to be sunny. By midmorning a cloud front may be drifting across the land. That's the time to abandon the backlit leaves and look to the sky. I find that I am aware of cloud patterns from having first observed them through my wide-angle lens. On the prairie the cloud formations often encompass vast areas of the hemisphere, the total pattern usually missed by the naked eye.

If you are not one to rise at 4:30 on a June morning, catch the daybreak in December at a more respectable hour! The early light can do wonderful things to snow!

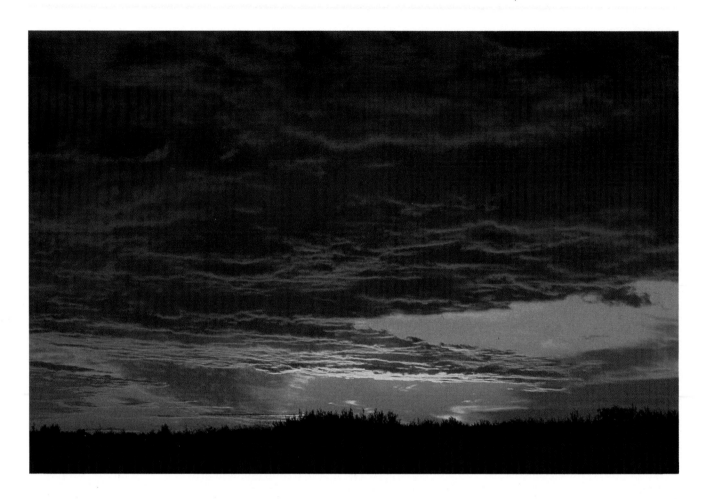

SCARLET SUNRISE

Ek 64
55mm lens
—½ exp

 Sunrise comes early to the prairie because the horizon is low and flat. The moment before the sun appears is a time of magic. A beginning, a greeting, an anticipation and a celebration all at once! I fumble frantically with last-second camera controls to record the color before the sun appears. My excitement combines the necessity of working quickly with the undeniable joy of the moment.

 No filters were used to record the dawn light on the clouds.

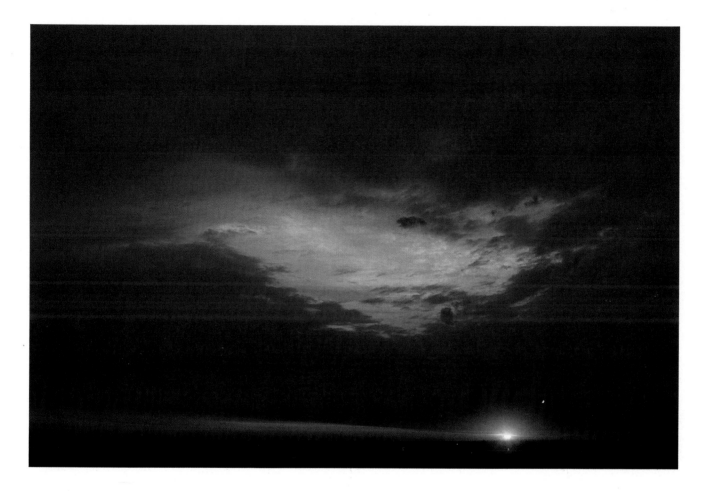

SUNRISE SUNSET

K 25
24mm lens
exp for sky opening

 I woke shortly before dawn and sat on a hill to witness the sunrise. A tiny sliver of brilliance and my heart quickened. I managed several exposures, then the sun disappeared for the rest of the day—earliest sunset I've ever seen and the only time I can remember watching the sun set up!

7

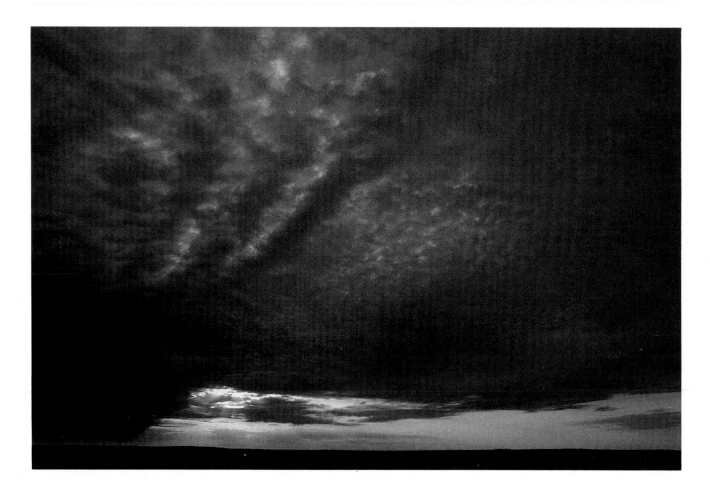

DAWN CURTAIN

K 25
105mm lens
−1 exp on wrinkles

Sometimes the clouds will wrinkle and fold like a stage curtain, which draws back to reveal another prairie spectacular. With tripod and camera on my shoulder and extra film in my pocket, I set out to record the morning colors.

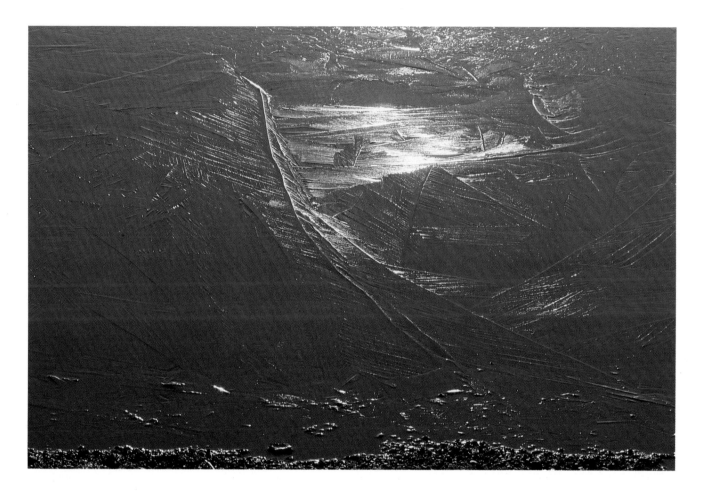

ICE SCULPTURE

K 25
50-250mm zoom at 250mm
−1 exp on left side

At sunup the light is warm and strikes at a low angle enhancing the shapes and textures of the ice sculpted during the night. As it climbs and warms the air, the sun will quickly destroy the artwork that it helped to create. You have to act deftly and with precision when you photograph on thin ice!

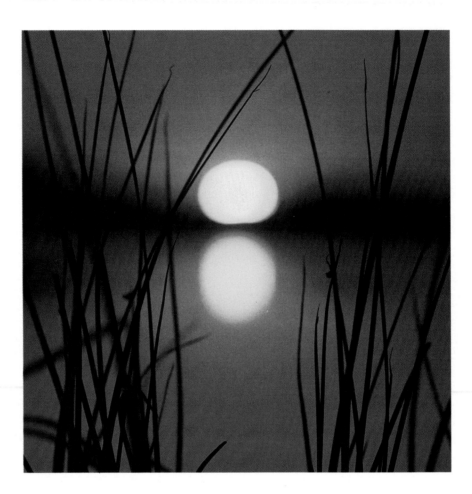

SUNRISE REFLECTION

K 25
55mm macro lens
—1½ exp on the sky

A dramatic sunrise over a windless lake lets me play with the mirrored duality of shapes and color. When I saw the sun break on the horizon I quickly sought out a foreground to harmonize. Though the reeds crossed at the top I placed the frame at their intersection to form a gothic arch for the sun's triumphant arrival.

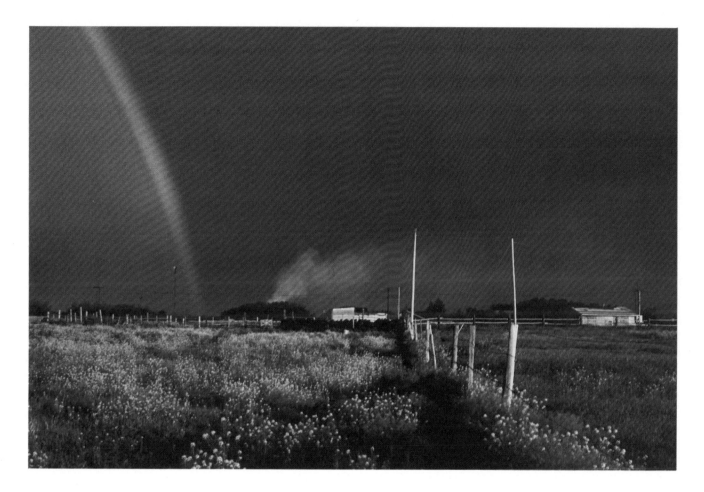

WILD MUSTARD

Ek 64
35mm lens
−2 exp for sky

 I love weeds! In mid-June the wild mustard blooms. If there is a good rain followed by hot sun, whole fields will explode in a profusion of yellow. The first rays of direct sun provide a light-bath for the western sky. Exposures are sometimes difficult because of the contrast of highlights against predominantly dark cloud.

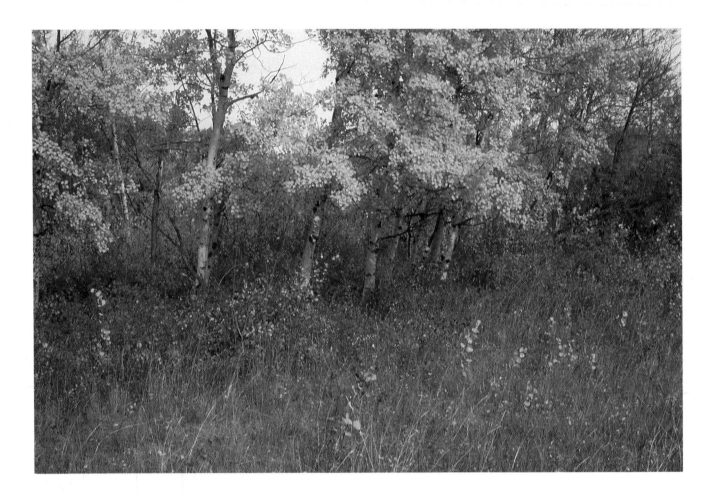

MORNING GOLD

Ek 64
55mm lens
—½ exp for grass

Early morning light is often accompanied by calm and silence. In September the cool night air may linger for a few minutes after sunup but the light is warm and inviting. If the fall days remain windless, the poplars will retain their autumn dress much longer; an hour of fierce wind can strip their limbs bare. Never do the trees seem more festive than when greeting the rising sun.

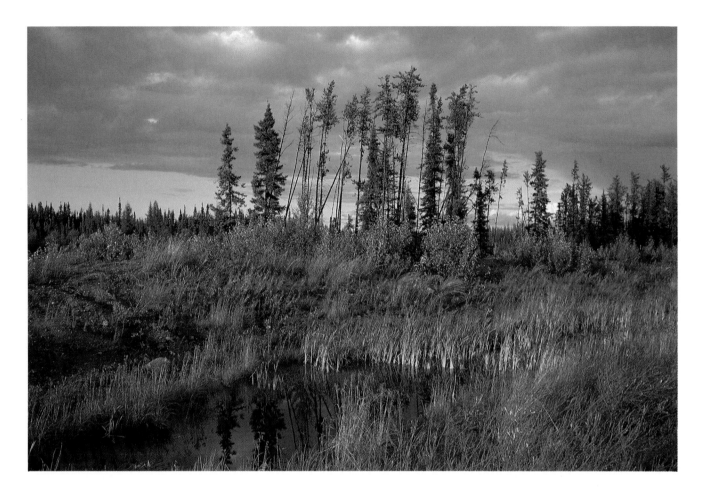

NORTHERN MARSH

Ek 64
50mm lens
— ½ exp

One does not normally associate evergreens with the plains. The Prairies are bordered on the north by the Canadian Shield, a flat land of forests, rocks, lakes, and muskeg. The division between the grassland and the Shield is abrupt, characterized by bogs, marshy areas crowned with spruce and pine amidst hay and alfalfa fields. The morning air is damp and sweet, a time to awaken the senses.

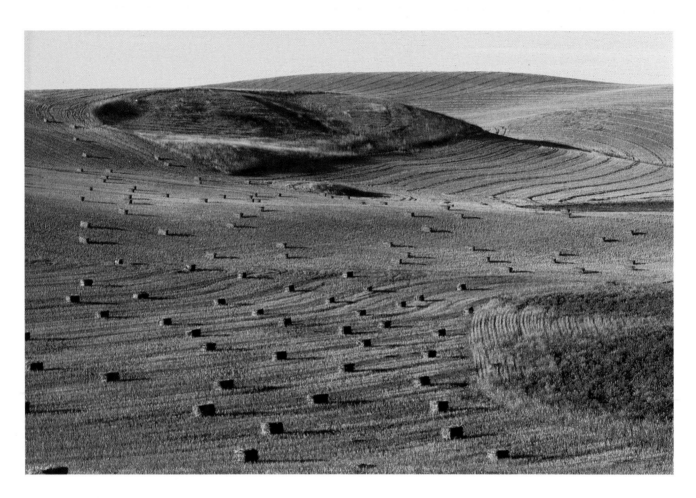

SIX A.M.

Ek 64
105mm lens
—½ exp

Watching the light an hour either side of sunup is such a
visual treat that one becomes spoiled by it. The midday light
is cool and often harsh by comparison. *Six A.M.* represents an
early attention to unorthodox design in my landscapes. Prior
to this, I would not have placed the green area so far to one
side. The sun, low on the horizon, produces a strong
side-lighting effect, which gives texture and depth to the
landscape.

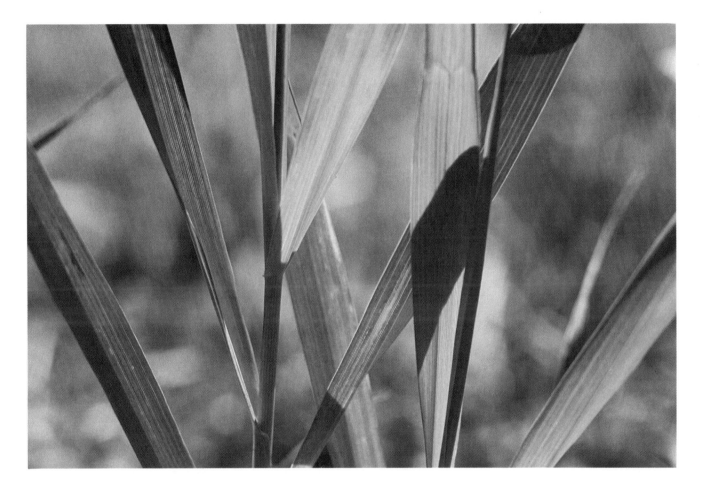

GRASS PATTERN

Ek 64
55mm macro lens
normal exp

Although it is only August, these blades of grass, backlit by the newly risen sun, are already turning color. Maybe my father was right after all. He used to say, ''The prairie has only two seasons: winter and exhibition week!'' I found this patch of grass in a ditch beside the road. Everything around it was a lush green. Grass and leaves have a dramatic flair, saving their liveliest colors for the end.

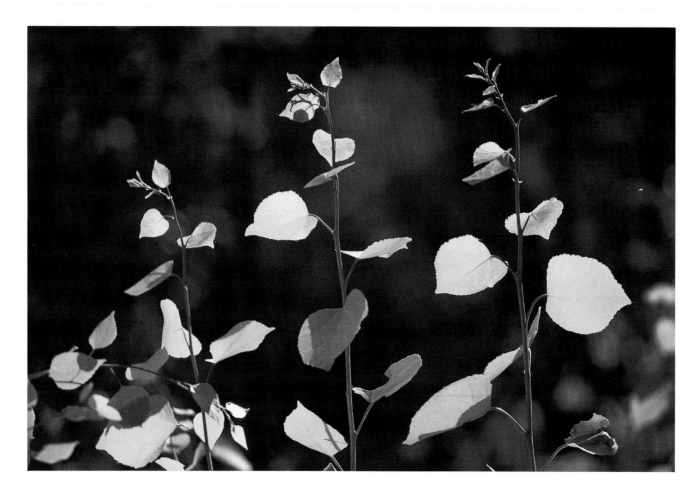

BALLET LESSON

K 25
55mm macro lens
normal exp on leaves

"All together now. Keep your leaves pointed and your
stems tucked in." The ballet lesson was well in progress when
I found these leaves beginning to turn color. In both
photographs, the leaves are backlit by a bright midmorning
sun.

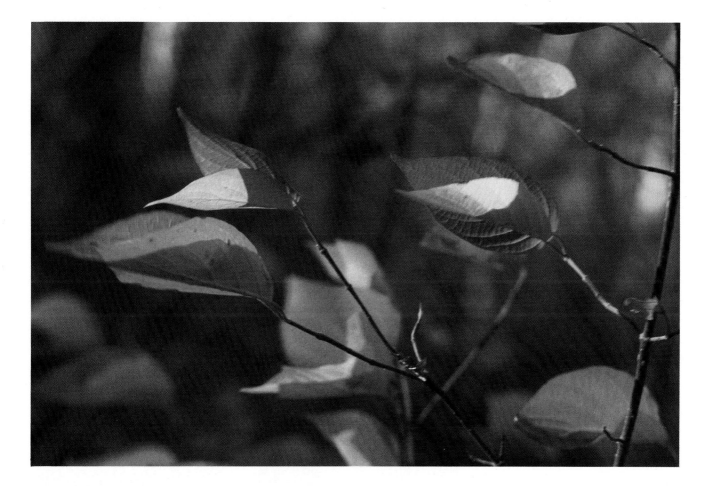

BLOWING LEAVES

Ek 64
70-210 zoom at 150mm
normal exp on leaves

Many people know W. O. Mitchell's book whose title asks,
"Who has seen the wind?" This photograph is my response.
Nowhere is the evidence of prairie wind more apparent than
in the autumn leaves all leaning in one direction. On a sunny
October day the leaves look warm and cheerful, but the wind
can still chill to the bone.

A SILVER LINING

Ek 64
105mm lens
—2 exp for sky above

Hoarfrost adorns the winter landscape. Mist or fog condenses on tree branches and freezes into crystalline structures. When backlit by the morning sun, nature's jewelry shines like diamonds. In December I can sleep in and still be on time for the "early morning" prairie light.

18

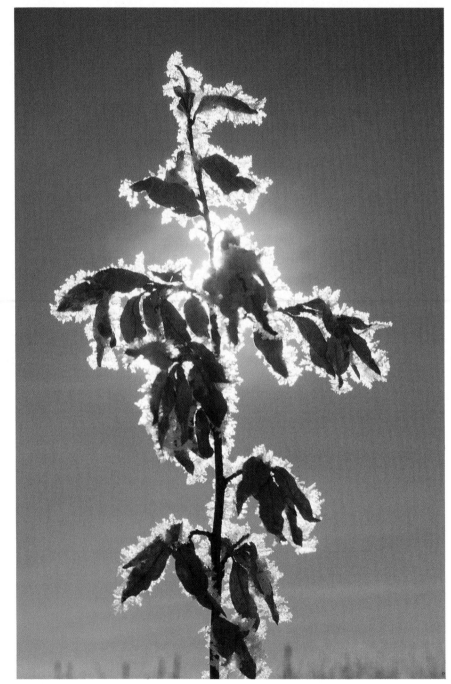

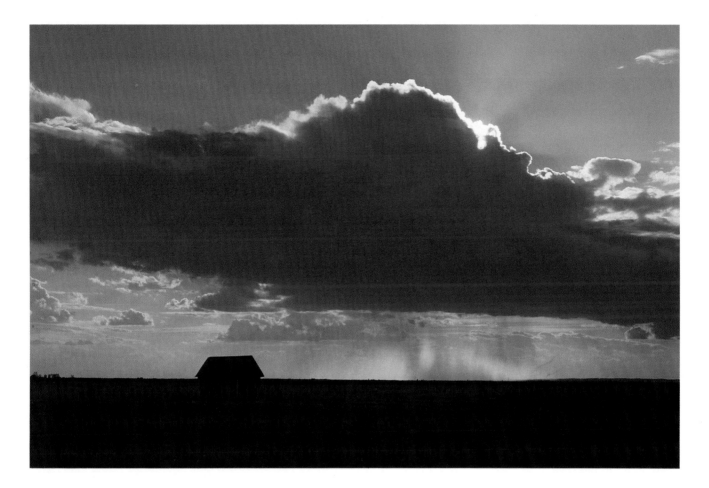

DISTANT RAIN

Ek 64
70-210mm zoom at 100mm
—½ exp for sky below cloud

Because the land is so flat and the view unobstructed, impending storms can be seen a great distance away. Present-day farmers have become as adept at predicting the weather from the sky as were the early settlers, who relied on good weather for safe travel. The shed is dwarfed by the looming cloud, captured just before the sun would emerge and change the mood of the scene once more.

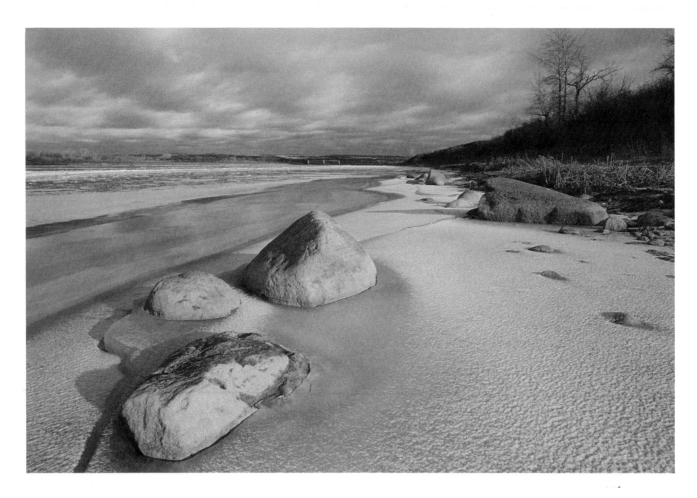

SPRING ICE

Ek 64
17mm lens
—½ exp

A scene on the North Saskatchewan River a week or two before spring breakup. The clear stretch has thawed and refrozen while a recent snow on the shore is beginning to melt in the morning sun. I had often noticed the river when crossing it on a nearby bridge, but had not gone down to explore. From ice level the rocks look larger, the perspective stronger, and the textures more defined.

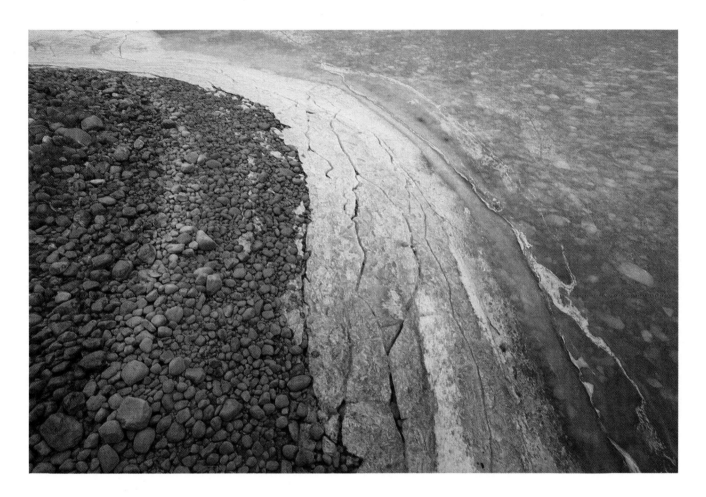

THE RIVER'S EDGE

Ek 64
24mm lens
normal exp

My view of the prairie has changed as a result of looking at other artwork. I used to find green ice uninteresting. After studying Toni Onley's watercolors, I am now attracted to landscapes of green and brown. There is no greater tribute to an artist than having influenced another's perception.

21

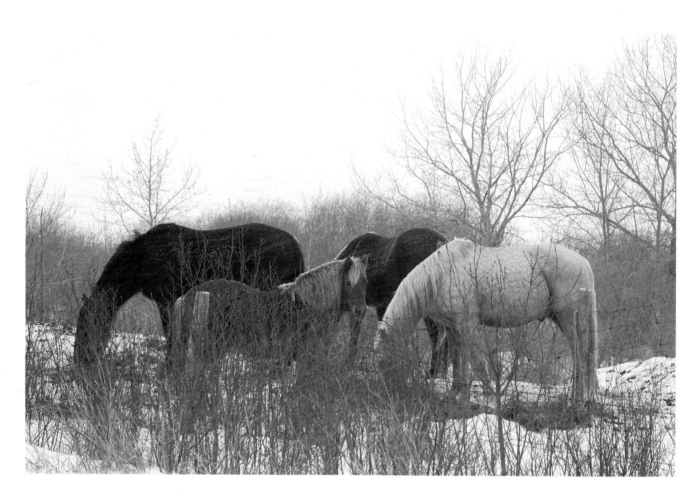

WINTER FORAGE

Ek 64
70-210mm zoom at 210mm
normal exp on bushes

It was a mild snowy day when I found the three horses and pony foraging on the remains of a hay bale. I wanted to catch all four with their heads down to show the repeating curves of their necks and backs but they wouldn't cooperate. Always one or more would watch me while the others fed. In 1982 I was asked to present one of my photographs to HRH Princess Anne on behalf of The Canadian Save the Children Fund; the selection committee chose this one and I have since come to like it more and more!

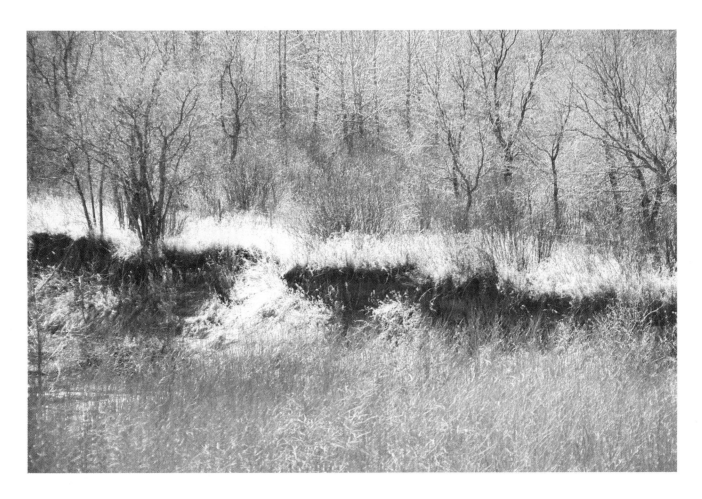

SPRING WILLOWS

Ek 64
105mm lens
+½ exp

Often by April the snow has melted, to return to the
prairie, one hopes, only for brief periods. It is a season of
muted color that holds a special quiet beauty. I allowed a
little more light than my meter indicated to catch the delicacy
of the tones, the rusty reds of the willows displayed against
an almost colorless backdrop.

LAST YEAR'S STUBBLE

K 25
70-210mm zoom at 80mm
—½ exp

Spring is best captured by the camera when most of the snow cover has melted leaving patterns where drifting or caking has occurred. To get above the patterns, I often photograph from the roof of my camper which I equipped with a metal ladder and plywood platform.

24

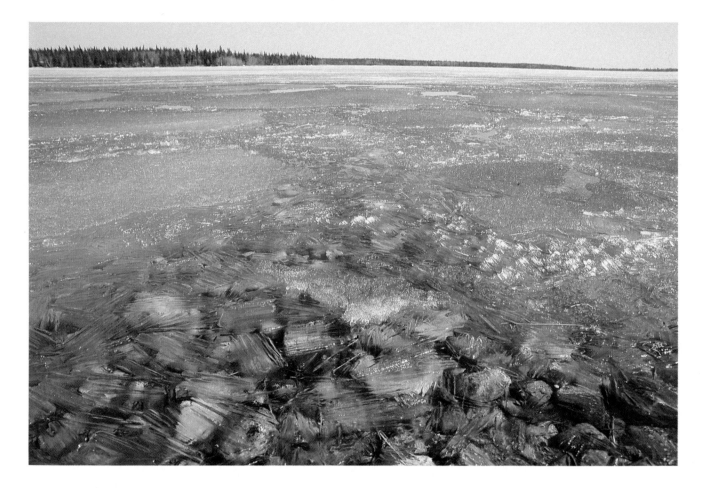

CANDLE ICE

K 25
17mm lens
—¼ exp

When the lake ice thaws, it breaks into vertical chunks called candles, that loosen from the edge of the flow. On a windy day in April the air is filled with the delicate chimes of the ice orchestra. Thousands of tinkling candles bob and brush in unison, a celebration of the coming of spring.

25

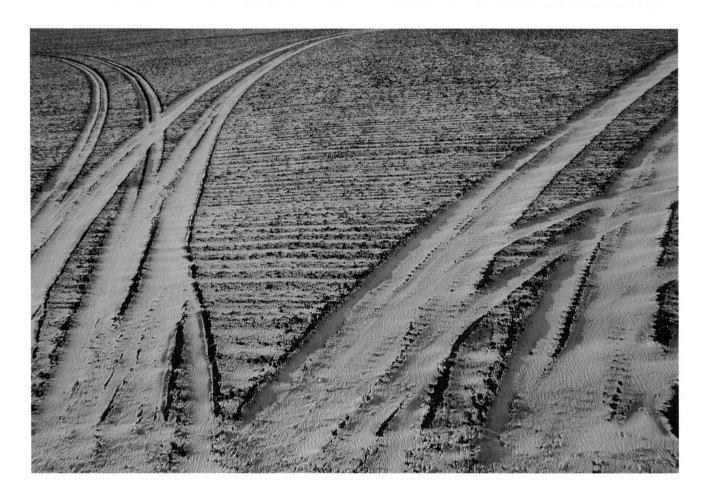

SNOW PATTERNS

Ek 64
24-48mm zoom at 30mm
—½ exp

It's May and we've been hit by a blizzard! Many of the waterfowl have already returned and the cattle have given birth to their young. These storms, though brief, can take their toll in wildlife and farm stock alike. Birds are unable to fly because of the buildup of wet snow on their wings.

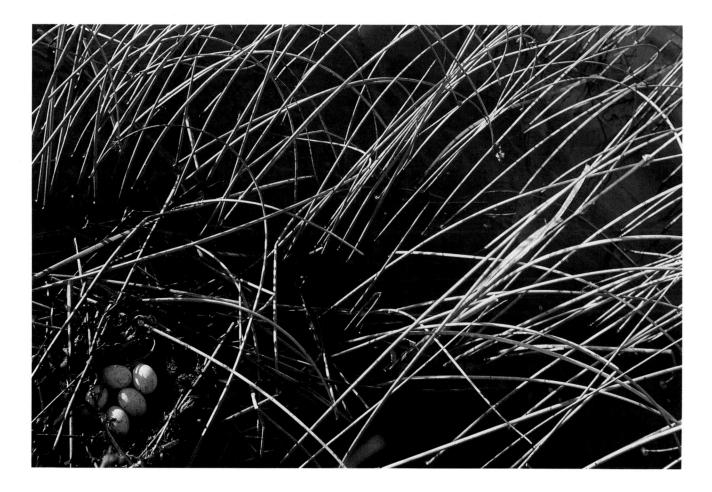

GREBE'S NEST

K 25
17mm lens
−1½ exp

Birds that survive the spring blizzards soon mate and lay their eggs. Waterfowl often build their nests in reeds away from shore predators but accessible from the water. Spotting this nest from my canoe, I paddled close, stood on the gunwales, and photographed with a wide-angle lens. I used the reeds as the mother grebe intended, to divert attention from the nest.

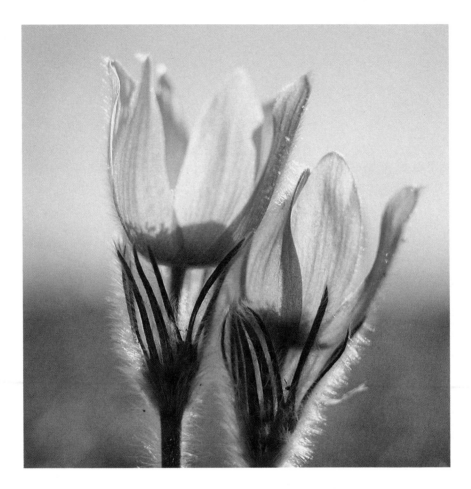

WINDBLOWN

K 64
55mm macro lens
+ ½ exp for flowers

"The prairie is awake, the prairie is alive," are the haunting words of the songwriter, Graeme Card. I am reminded of the crocus, the first flower to brave the cold spring winds and unpredictable temperatures. Like our prairie ancestors, the crocuses stand defiantly, battle the elements for survival, and proudly reach for the sun.

28

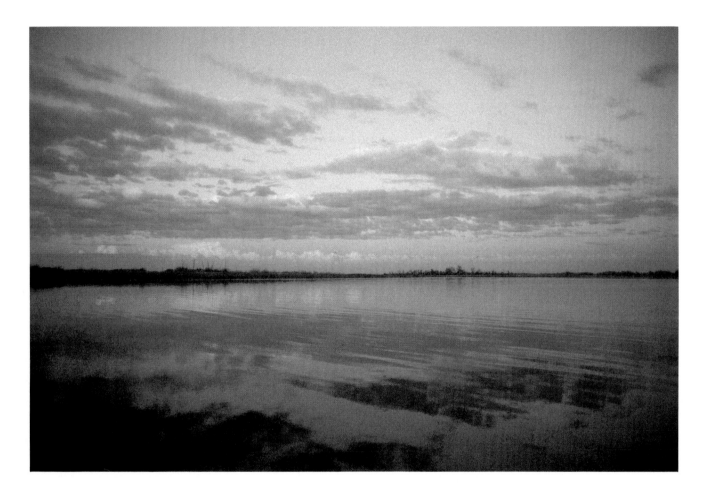

SPRING MORNING

Ek 64
24mm lens
normal exp for sky

Spring and morning share the theme of awakening. Both make us feel alive and in touch. As the sun climbs higher it gives a warm welcome like no other time of day. We think of morning as nine to twelve, but in the world of prairie light, the gradual change is imperceptible.

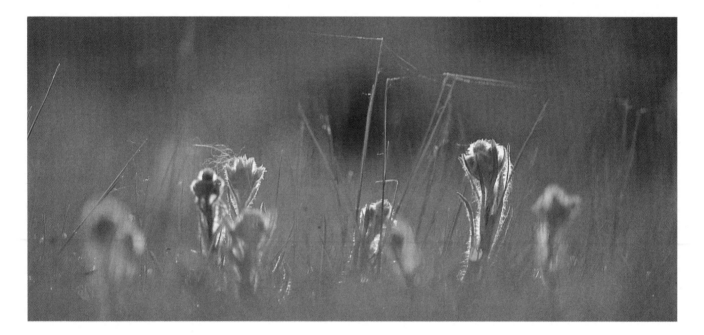

JOY OF SPRING

Ek 64
70-210mm zoom at 210mm
—½ exp for scene

It's amazing how different the prairie looks from different heights. To the gopher, emerging from a dark cold winter of hibernation, it must appear as a welcome, joyful place. In the morning the grass is like a cathedral, the silver candlesticks polished and glistening in the sun. But even sanctuaries have their problems with spider webs!

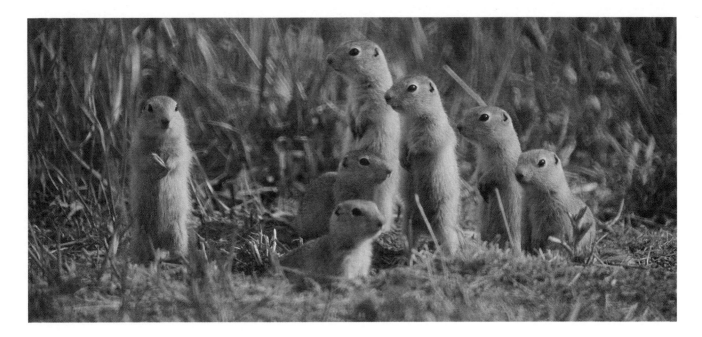

FAMILY PORTRAIT

Ek 64
500mm mirror lens
—½ exp for scene

I share my yard with fifty gophers. Each spring when the young are allowed out, it is a tradition for us to do family portraits. They seem to love showing off their new fur coats for the camera. Getting the whole family to hold a pose can be a problem. The best method is to make an almost inaudible squeal like their danger signal. They all run to their hole and then stop, waiting for my next command. Click, and I thank them for their cooperation.

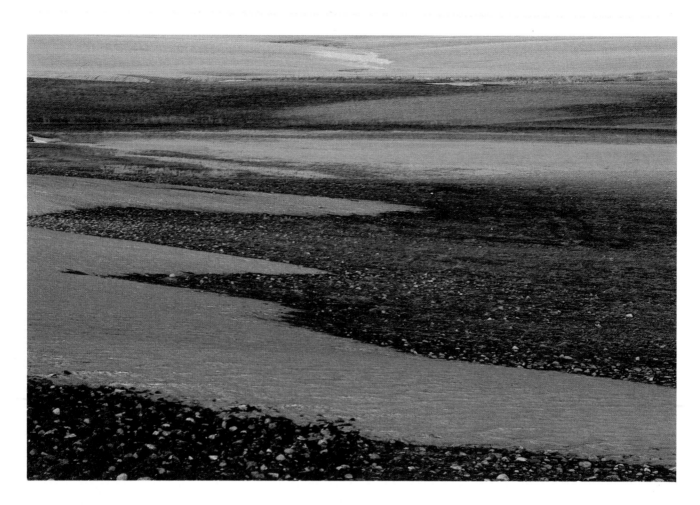

SPRING SNOW

K 25
70-210mm zoom at 210mm
— ¾ exp

The interplay of colors can sometimes be the most important ingredient in a landscape. For me this picture conveys the joyful experience of being out on the land in the spring. The dark blue shapes are snow drifts while the turquoise band is spring runoff which has refrozen. Beyond lies the stubble left from last year's harvest.

32

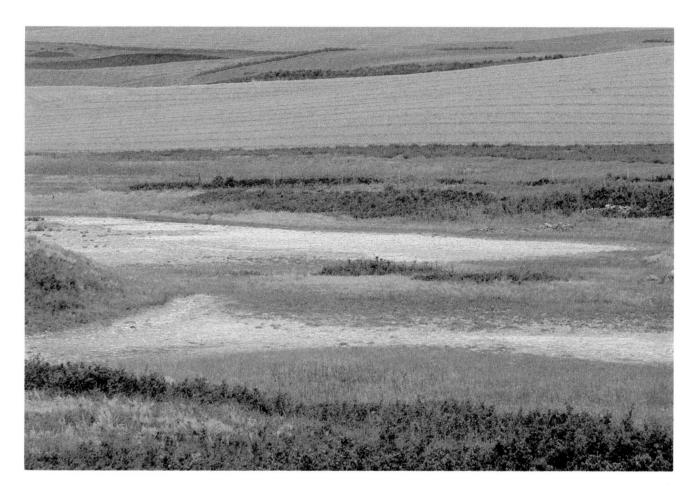

COLOR PATTERN #57

Ek 64
200mm lens
—½ exp

As the sun gains height, the prairie tones flatten; shadows disappear and the feeling of perspective is reduced. This alkali slough has dried and turned to a white crust, a color contrast with the surrounding farmland. In wet seasons, a farmer must avoid seeding these areas, thus lessening his potential harvest. What's an eyesore to the farmer can be a tapestry of color for the artist.

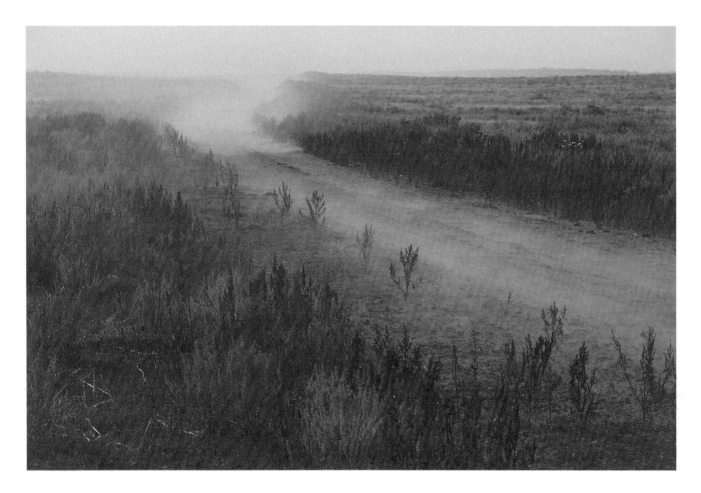

EATING DUST

K 25
70-210mm zoom at 70mm
normal exp for road

The "dirty thirties" was a desolate chapter in the life of the Prairies. Lack of rain meant little or no moisture for the crops and little or no income for the farmer, and that put financial burdens on everybody. It also meant ten years of incessant dust as the wind raged without mercy. Many turned their backs on the wind, and on the prairie. A dust storm now is a grim reminder to those who stayed it out.

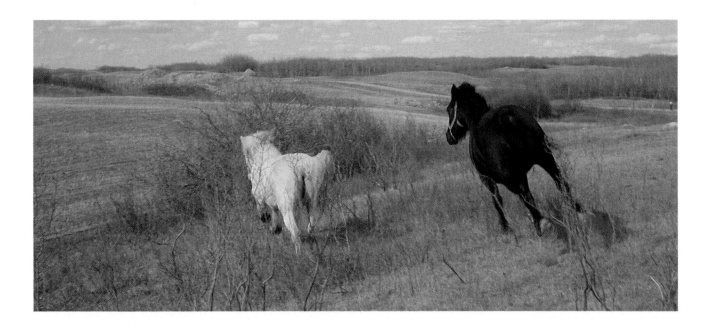

THE CHASE

Ek 64
55mm macro lens
—½ exp for field

I was burrowed into a close-up of a crocus when I heard a great commotion and the pounding of hoofs. These two horses were in hot pursuit of my dog who promptly hid behind me! I leaped to my feet as the black one reared up in front of me. Holding my ground and trying not to show fear, I quickly reset the focus on my macro lens from twenty-four centimeters to infinity. Time enough for a couple of exposures as the excited animals beat a hasty retreat.

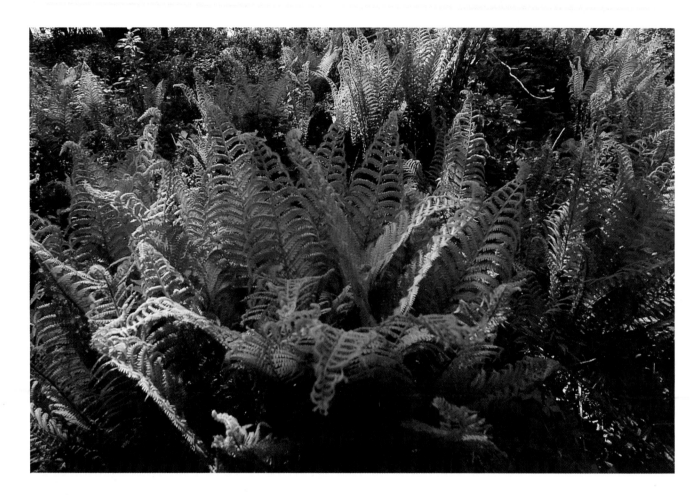

PRAIRIE OASIS

K 25
17mm lens
−1 exp

A profusion of ferns on the bank of a river is an aspect of
the prairie landscape usually seen only by those who explore
by canoe. Though the rivers cut through farmland, few roads
lead to the water's edge. These ferns have found a virtual
oasis where they may thrive despite heat or drought,
protected by the overhang of the leaves above.

36

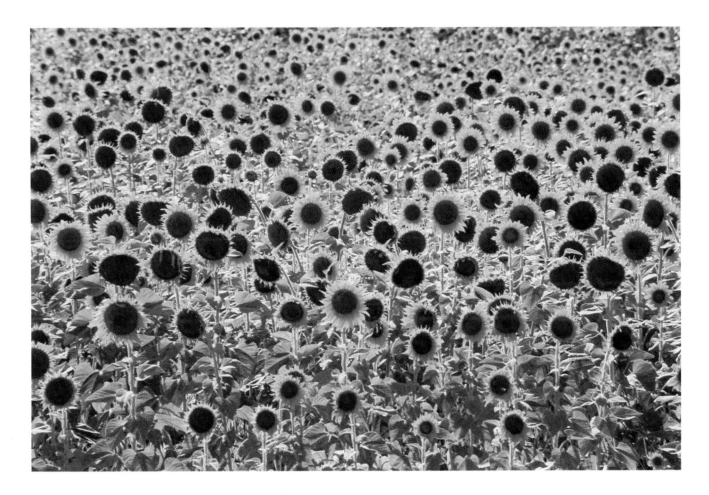

SUN WATCHERS

Ek 100
80-200mm zoom at 80mm
normal exp for scene

By mid-August many of the sunflowers have discarded their yellow bonnets, and with more exposure their countenances have darkened. But regardless of their maturity, all heads turn to face the late morning sun. Like prairie folk, young and old become spectators to the sun's grand parade across the summer sky.

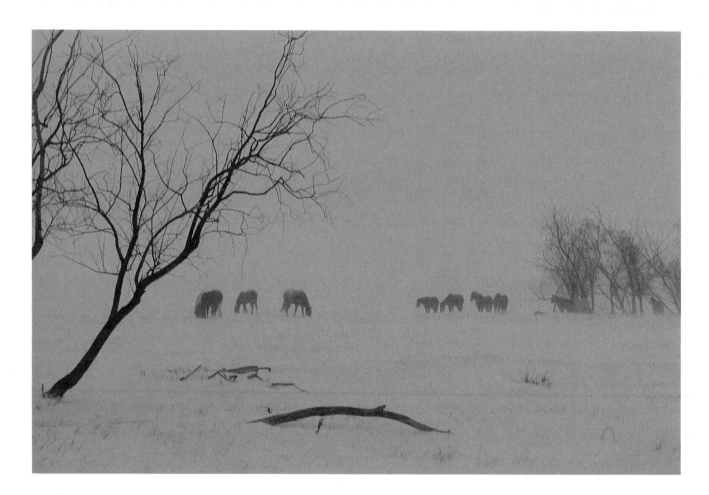

FORAGING IN THE STORM

Ek 64
55mm lens
+½ exposure for scene

My session photographing these horses was one of the coldest I have ever experienced. At minus thirty-five degrees Celcius the camera batteries die when exposed for three minutes. I kept the camera inside my buffalo coat and forced myself to walk into the numbing north wind. By composing the picture in my mind's eye, rather than through the viewfinder, I kept the camera protected until the last few seconds. The stark lines of the foreground tree help convey the feeling of the biting cold.

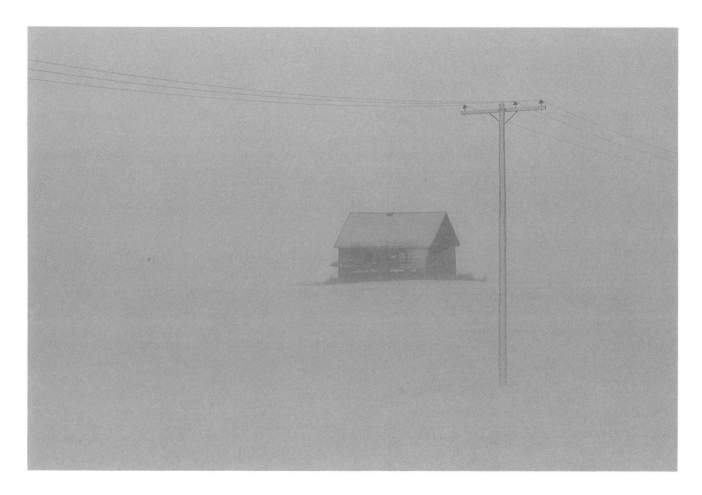

SILENCE

Ek 64
70-210mm zoom at 150mm
+½ exp

Because the winter air is so cold on the prairie, the snowfall is mostly dry. Sometimes, however, during a chinook from the west, or in early spring, the snowflakes are large, coating the windward side of everything they fall upon. Wet snow rarely lasts more than a day before melting or blowing off but in the meantime it makes fine "pencil sketches" to photograph. When the wind abates and the world is coated white, you can hear the sound of silence.

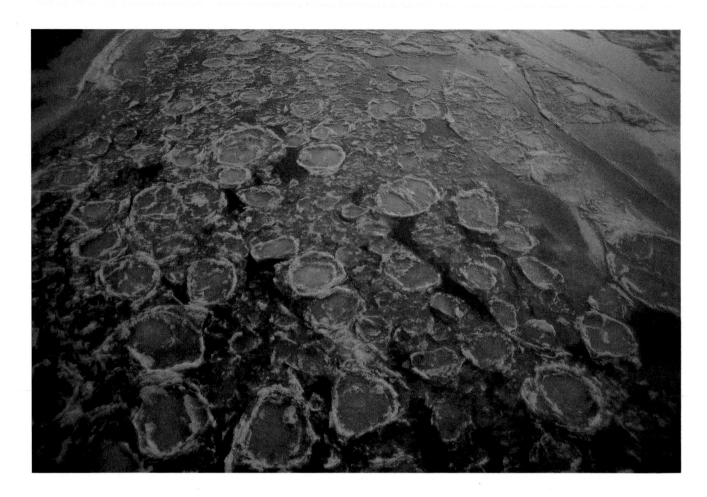

SPRING BREAKUP

Ek 64
24mm lens
— ½ exp

It used to be that the breakup of river ice was a special occasion. It began with a crack like a rifle shot as the ice was forced loose. Then came the flow of huge chunks as wide as houses and up to three meters thick that floated from the Rockies to Hudson Bay on the South Saskatchewan River. Nowadays there is less of a spectacle. The earth-filled dam forming Diefenbaker Lake has reduced the volume of water and restricted the flow. In this photograph, the ice has jammed and the water surface refrozen.

40

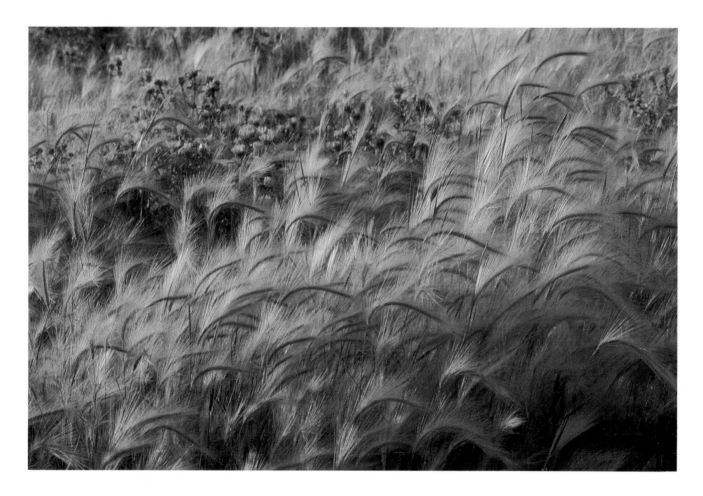

SUMMER MAGIC

Ek 64
105mm lens
normal exp

A burst of sunlight from behind gave these foxtails a luminescent glow. Although I was on my way to an appointment, I took time with my camera to enjoy the play of light and texture, such unforeseen delight.

41

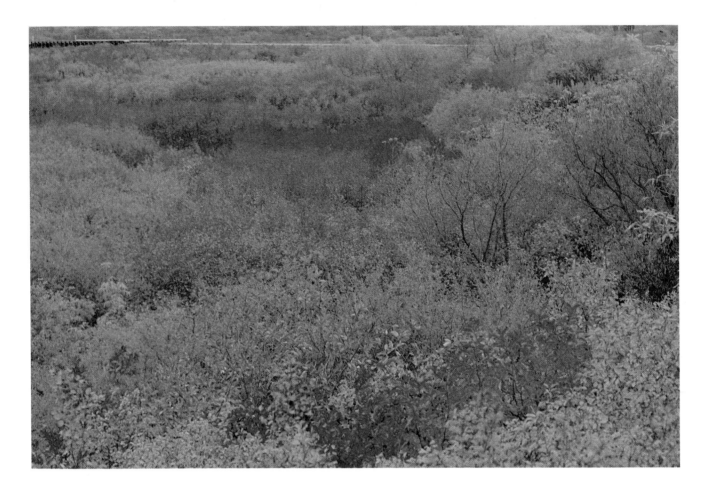

AUTUMN PALETTE

Ek 64
55mm lens
normal exp

Autumn on the prairie can last for months but its most festive color is shortlived. On one or two days each year, a complete range of color splashes across the land. The hues of the leaves, grasses, and reeds change in a succession of moods. Then the brighter colors fade as the leaves dry and wither. Many people find it surprising that the best time to record the nuances of color is in the overcast light of midday.

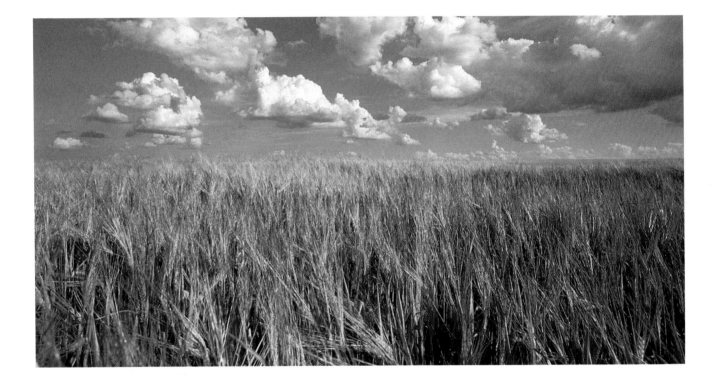

THE LIGHT OF DAY

When the summer sun reaches its zenith, as in the photograph on the facing page, it often brings wind and heat. The unknown factor is rain. A thunderstorm in July can be worth millions; but it's the long, slow drizzles that saturate the soil, building a reservoir of nutrients. Then, more sun is needed to mature the grain.

Prairie light has an infinite number of moods and temperaments. Like exploring a human relationship you can keep going back again and again, each time finding something new. Revisiting the same place in different seasons can be as new and fresh as discovering it for the first time. There are spots on the Prairies I have gone to on more than fifty occasions. No two visits were exactly alike.

First and foremost, a landscape photographer must respond to the quality of light. For this reason one must be exceedingly careful about generalizations. The technique I used yesterday might be completely different from what seems appropriate today at the same hour and location. Camera technique is my response to what is interesting, which often depends on the play of light.

If the day is bright and sunny and the subject matter casts observable shadows, I will tend to choose Ektachrome. Many of the pictures in this book were made with Ektachrome, not surprisingly as many of the days are sunny! But they are also windy. Midday announces the arrival of

the wind with the rustling in the birch and poplar and the whisperings of prairie grasses. Now for the supreme challenge: to make a picture that lets the viewer feel the wind, smell the air, taste the dust. Through the sense of sight alone I must conjure a reality that brings the other senses into play. I can't record the song of the wind with my camera but I can document its effect on swaying branches, blowing leaves, and waving wheat fields.

On overcast days I tend to shoot Kodachrome. It responds best when there is little variation in tones, such as the even, shadowless light of a cloudy day. When harsh shadows are absent, it is relatively simple to obtain an exposure that portrays good color and detail throughout the picture space. Often I leave the horizon line out of the frame altogether because the sky, particularly in the direction of the sun, is distractingly bright. Paradoxically, an overcast sky can be more difficult than a sunny sky because the whiteness on an overcast day is proportionately brighter than is a blue sky above a sunlit landscape.

Even when the sun is shining, midday light can be even if the shadows are hidden. I photograph a lot from the platform on the roof of my camper in order to show more of the color patterns in the landscape. Regardless of the quality of light, the high vantage point affords a better view. After all, a three- or four-meter elevation on the prairie is high!

RAINBOW EXPRESS

Ek 100
28-80mm zoom at 35mm
+ ½ exp on sky

The prairie continues to delight me
with its limitless range of color and
mood. For many years I looked
only to the landscape as a source
of material for my pictures. I
would go to great lengths to avoid
including a fence, pole, or train in
my viewfinder. Seeing the variety
of hues in nature has now opened
my eyes to color elsewhere.
After spotting this train on a
siding, I spent the next hour
happily exploring shapes and color
combinations. The orange shed
was an extra treat to add to my
rainbow on the rails.

46

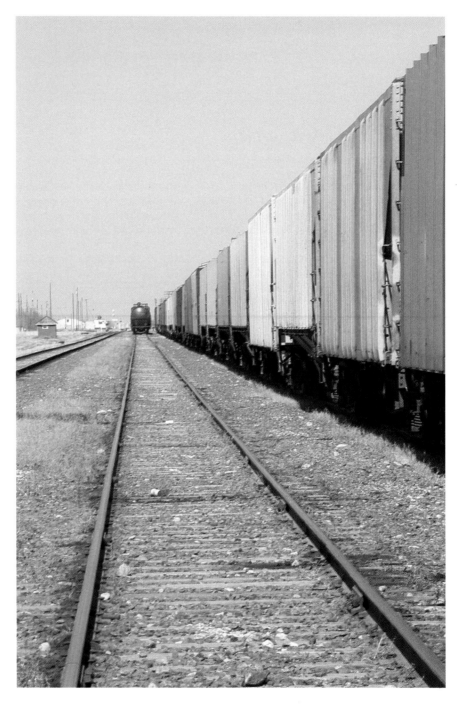

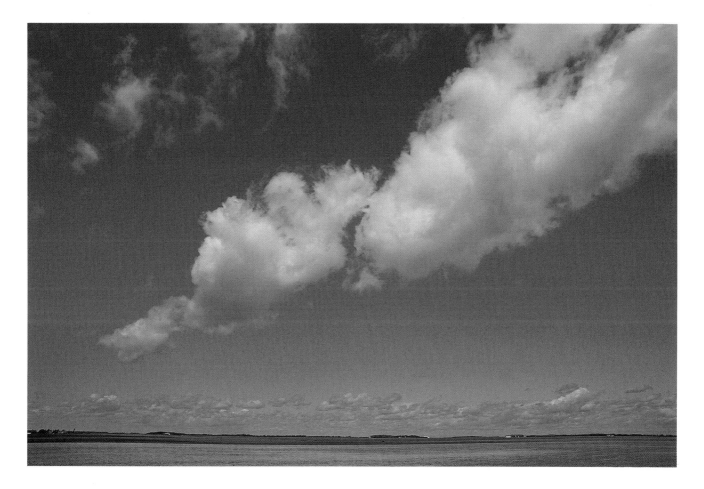

LYNN'S FIELD

K 25
24mm lens
−1 exp on sky above cloud

Sometimes an image of the present can kindle nostalgia for an age gone by, or convey a feeling of hope for the future. This scene does both for me. The cloud formation reawakens a boyhood memory of the steam locomotive chugging across the prairie, sometimes visible only by its trail of smoke. The oblique angle of the cloud and yellow of the canola field give the picture vitality and leave me uplifted.

47

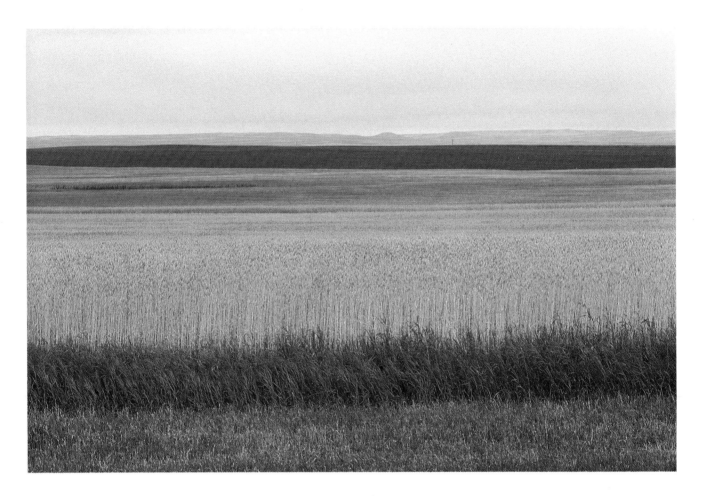

AWAITING HARVEST

K 25
70-210mm zoom at 210mm
normal exp on ripe wheat

"On a clear day you can see for a hundred years." In the
distance are the Blue Hills of Montana. No matter the season,
these hills always look blue in daylight. All the other colors
change with the sun, the rain, the lifecycle, and the season.
The prairie landscape knows no limit to its array of costumes.

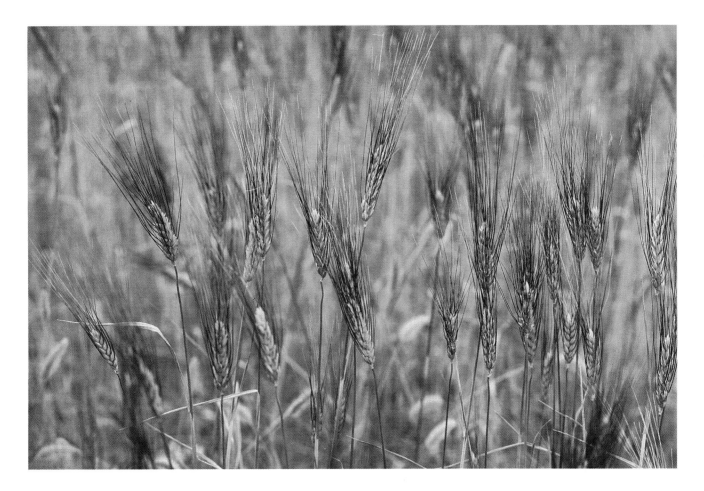

GREEN WHEAT

Ek 64
55mm macro lens
normal exp

 As I drove by this field, I saw the green heads of wheat
standing out against the gold stalks. Just like the farmer at
harvest, I aim to seek out only the kernels and get rid of the
chaff. Reducing the composition to two colors and focusing
on the heads help to achieve the simplicity. I threw the
background out of focus so the wheat heads would stand out.

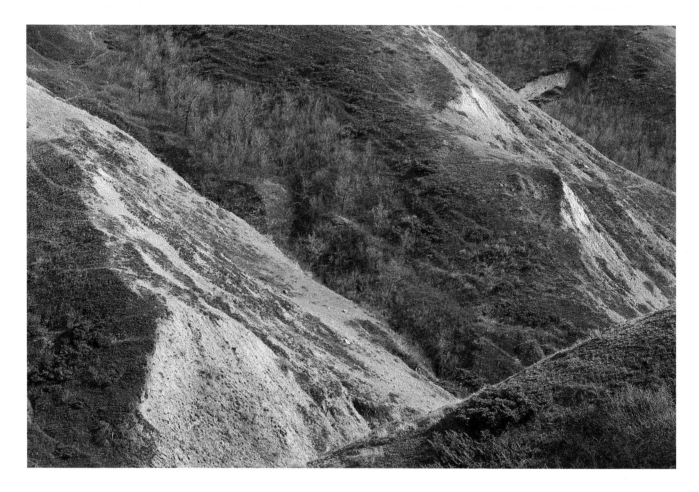

COULEE IN OCTOBER

K 25
105mm lens
−½ exp for bushes

 Coulee in October was made on a perfect autumn day when
the early afternoon sun transformed the great prairie sky into
a spiritual renaissance. The steep slopes have resulted from
streams carving their way through the hills to unite with the
river. The sides of these ravines often become eroded when
flood waters carry away their support. Where the incline is
less severe, small trees take root and deer bed down in the
resulting coulees.

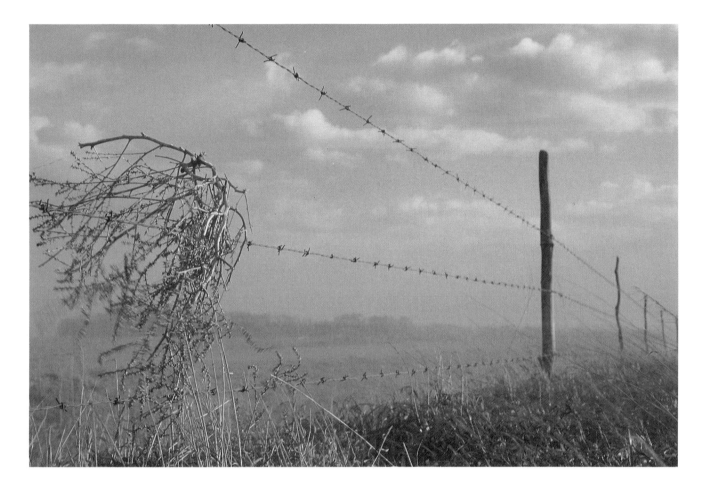

TUMBLEWEED

Ek 64
17mm lens
+½ exp clouds

Tumbleweeds, sage bushes dried out from lack of rain,
have come to symbolize drought on the prairie.

There's no avoiding dirt when I photograph in the wind
from a low angle. Getting into the thick of it can be great for
exposing film, but not for exposing the camera. After finishing
two rolls, the film advance lever refused to budge. Film *and*
camera were shot. I squeezed off the last frame, then took the
camera in for cleaning.

51

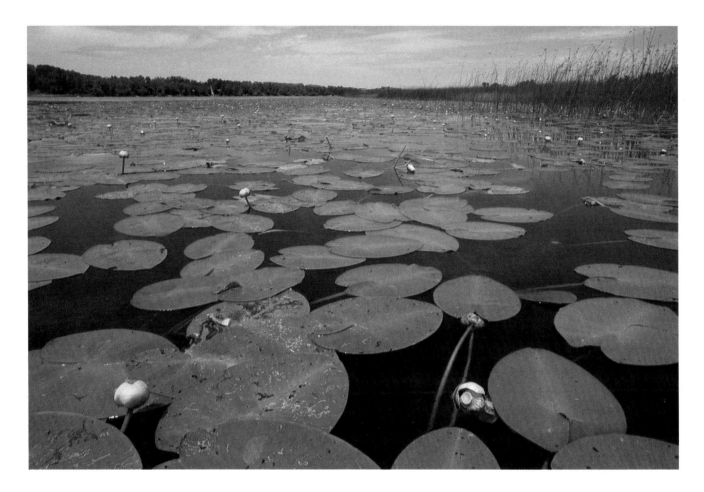

WATER LILIES

Ek 64
24mm lens
—½ exp

I once upset my canoe in deep water, camera strung around my neck. I had no sensation of tipping but remember looking through my viewfinder and seeing the lake rise up to greet me! As I hit the water I let go of the canoe, saving the rest of the camera equipment from any water damage. The water was icy. I clambered over the end of the canoe and paddled hard to shore. Oh, the drama behind the most serene of landscapes!

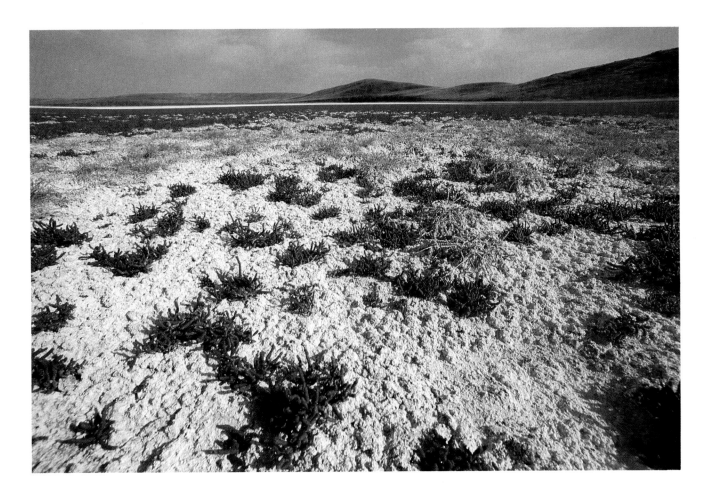

ALKALI FLAT

Ek 64
17mm lens
— ½ exp on alkali

By October the alkali crust displays its pockets of shadow even in the middle of the day. Because alkali sloughs are dried up lake beds, they are flat and are often surrounded by sloping land or hills. I like to photograph the sloughs from a low angle. They take on a perspective that makes the bordering hills look like distant mountains. The Red Samphire become red trees rising from a white desert, as seen high above the earth. Letting your imagination soar over the landscape is a marvelous release.

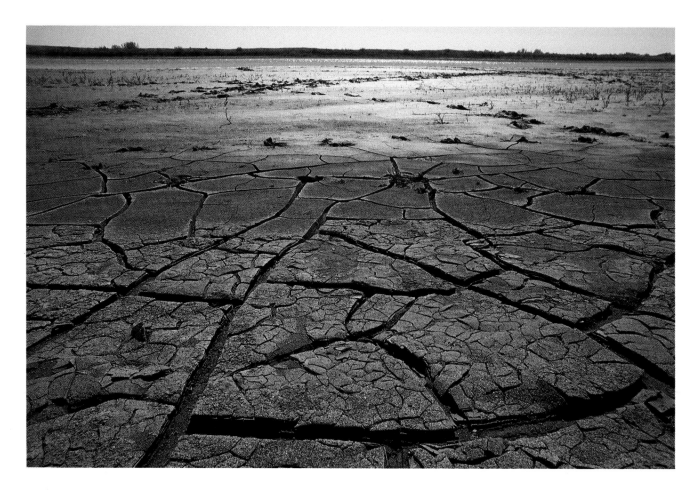

RIVER FLATS

Ek 64
17mm lens
—½ exp

By late July the midday sun is at full strength. In a dry summer it can bake land and lake until all is brown. With endless days of heat and no rain, a lake or river may drop a meter or more. If the bottom is flat the shoreline might recede a hundred meters. Only the parched mud flats remain where cattle once watered.

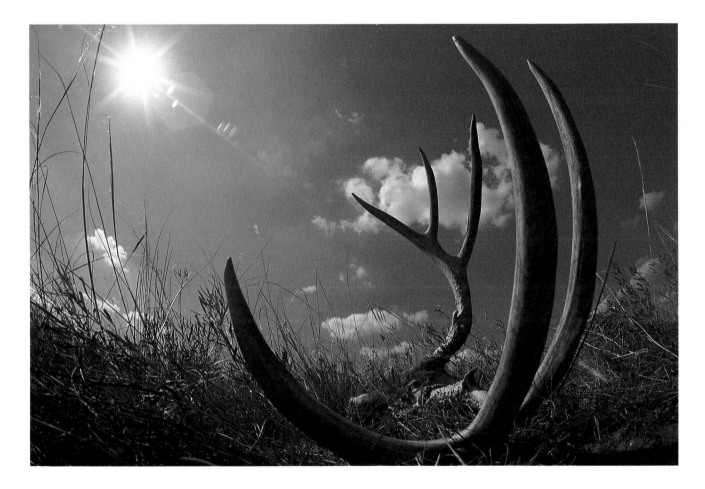

LIFE CYCLES

Ek 64
16mm (fisheye) lens
normal exp for center of sky

A walk on the unbroken prairie soil is a reminder of life's cycles. The rabbits and birds, rivers and lakes, earth and sky, each reflects the season. But finding the remnants of a life completed is the most poignant reminder of the inevitable conclusion.

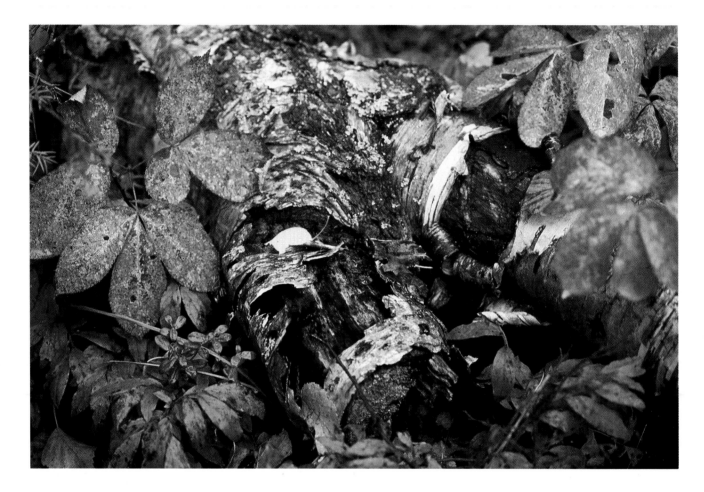

FALLEN BIRCH

Ek 64
55mm macro lens
—½ exp

When I photograph decay I often see its contribution to
new life and growth. But here the leaves fostered by the new
growth are also dying as if in sympathy with the old log. In
his album *Dorothea's Dream*, Graeme Card sings:

> It's only a short run to get to Regina,
> There's a million pit stops along the way.
> And every one of them is bright with colour,
> Because they're magic . . .

56 This is one of my pit stops.

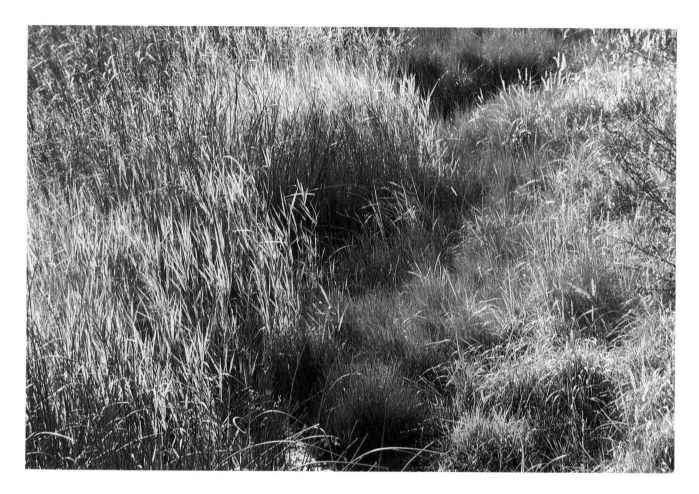

GRASSLAND PAINTBOX

Ek 64
70-210mm zoom at 70mm
normal exp

Early one August afternoon, the vibrant prairie colors prompted me to sing, even though I can't hold a tune. Since no one was around to offend, I bellowed out "the fields are alive with the sound of music." Suddenly I heard the sound of metal nearby and realized a farmer was working underneath his cultivator. Embarrassed, I let the last few notes trail away in the warm afternoon wind.

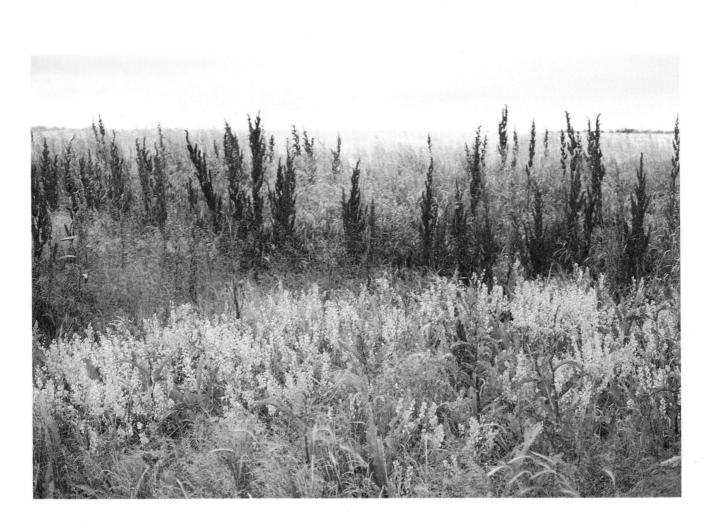

PRAIRIE GARDEN

Ek 64
105mm lens
normal exp on foreground

My front yard contains twenty varieties of weeds. When they get too large or too close to the front door I panic and mow. I fell the toughest ones with my machete, the motive self-defense. The rest of the time we share the property in peaceful co-existence. I'd rather spend my time photographing them than waging war.

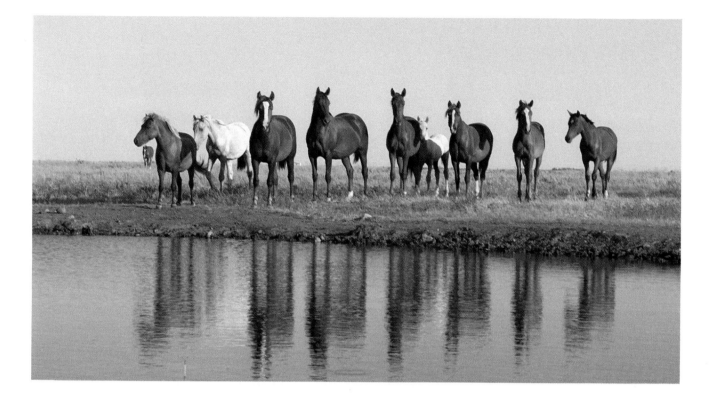

AT THE DUGOUT

Ek 64
55mm lens
— ½ exp on water

When I saw these animals pounding across the plain for
the dugout I quietly stretched out on my stomach, camera
cupped to my eye, and waited motionless. As soon as they
arrived, they sensed my presence. I had only time for one
exposure before they bolted. It's hard to remember to include
the reflection when concentration is on capturing the
moment. Landscape photography poses its greatest challenge
when the timing is critical, but when you get it, that's cause
for rejoicing!

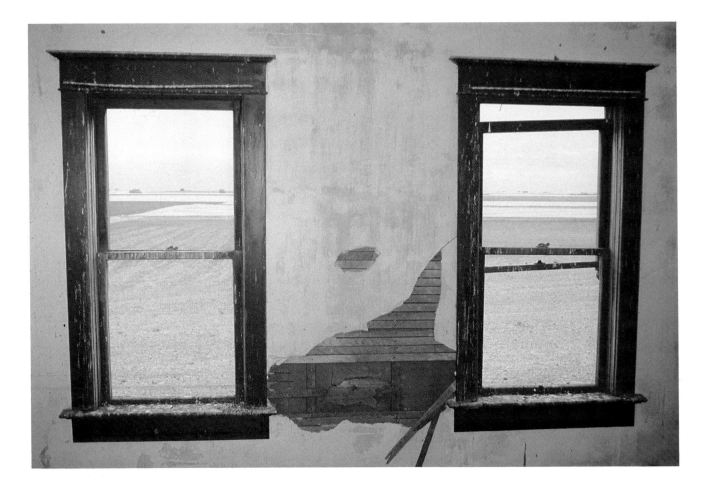

PICTURE WINDOWS

Ek 64
35mm lens
+1½ exp for field and fill-in flash for wall

This house was built in 1911; that's "old" on the prairie. It was purchased as a mail order kit for six hundred dollars from Eaton's in Winnipeg and shipped west by rail. The kit included the windows, bannister, plumbing, eavestrough, and paint. Oh, for the good old days!

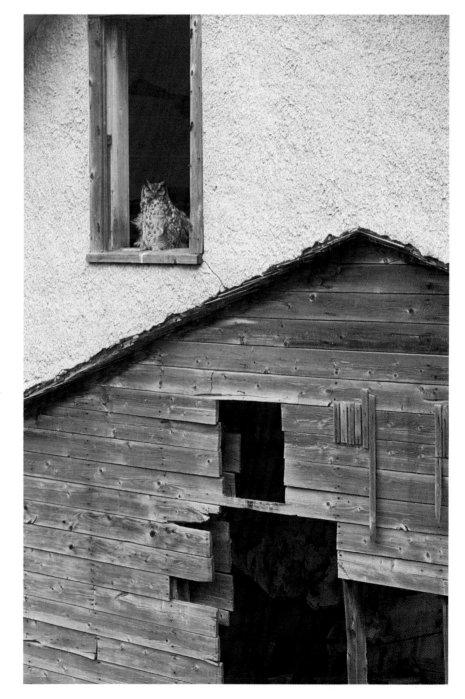

ABANDONED HOUSE

Ek 64
105mm lens
normal exp for stucco wall

I was startled and excited when I discovered this owl asleep in the window, but unfortunately I had only my normal lens with me. I crept away on a twenty-minute return trip to the car to find him in the same spot. One noisy clunk of my shutter and he was awake. I quickly caught this picture as he opened his eyes, indignant about my intrusion. I cocked the advance lever for a third shot, only to record a gray blur.

61

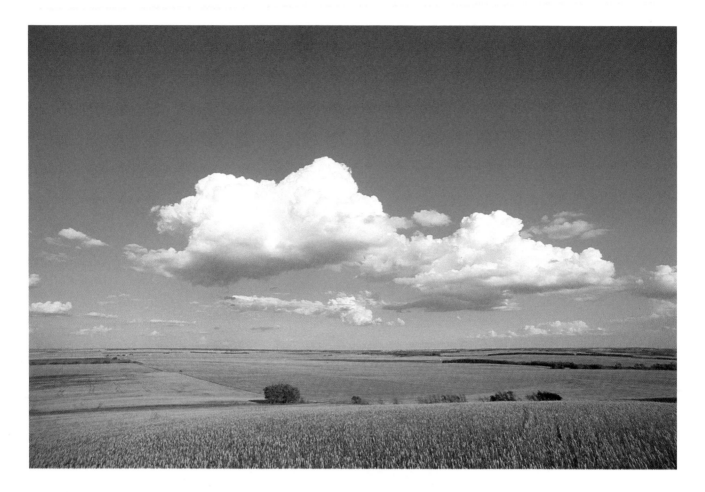

SCHOOL'S OUT

Ek 64
24mm lens
normal exp on field

Though this is a midsummer landscape, for me it conjures up the uncontrollable joy of getting out of school. Before me lay the wide open spaces, bright sunshine, and freedom! If you listen carefully you can hear us on the way home, skipping and laughing, crazy under a summer sun.

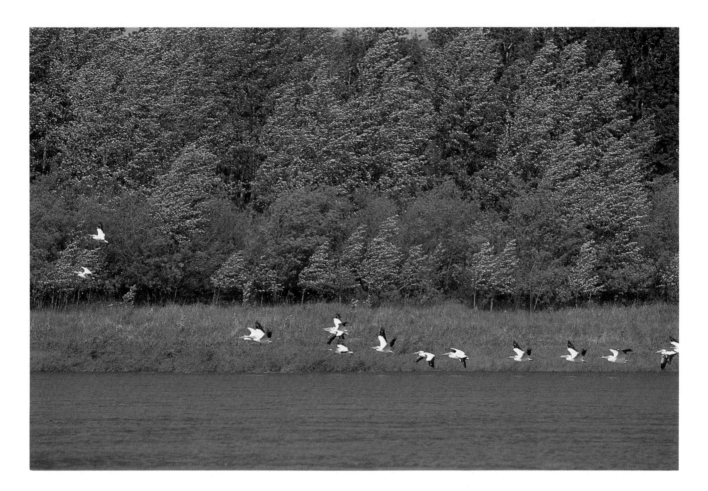

INTO THE WIND

Ek 64
70-210mm zoom at 70mm
−½ exp for trees

Catching sight of pelicans about to lift off from the river I had three or four seconds to assess my composition. The poplars at the water's edge were leaning in the wind, an ideal backdrop to complete the story. I set the shutter speed at 1/250 sec and slightly underexposed the trees. As the birds flew by they started to gain altitude. Click. Concentrating on the precise instant of exposure is more important than having a motor drive which can click off several frames a second.

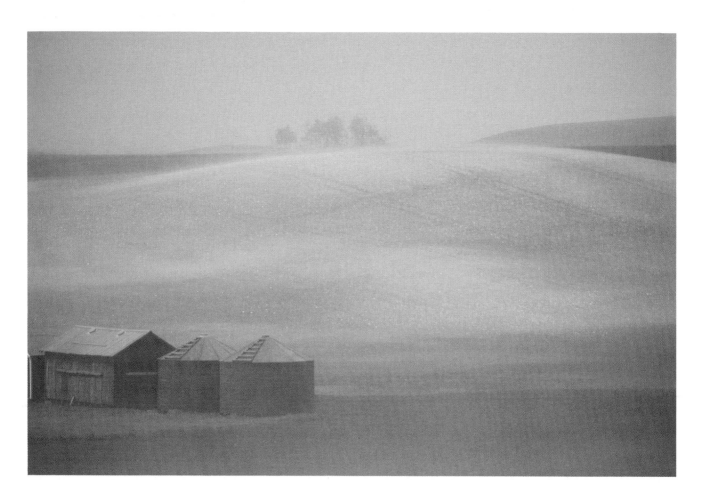

WINDSWEPT

K 64
50-250mm at 180mm
normal exp on hill

Compared to *Tumbleweed* (on page 51) this dust storm was relatively easy to photograph. While I was standing on top of a nearby hill, the dust was being funneled through the valley below. Fortunately, neither I nor my camera was in its path.

One of the desirable aspects of photographing a dust-filled landscape is the muted sky. Clear midday skies are often too bright compared to the tone of the land.

AUTUMN PINK

K 25
50mm lens
normal exp on scene

In late September a group of us were exploring on the river bank. The weather was mild but the sky was overcast. By midafternoon the sky had grown more somber and the autumn color appeared too dark to photograph. Several of the people gave up and went home. I came upon these willows and made a one-second exposure to get enough light. The leaves are blowing contrasted with the dark motionless trunks.

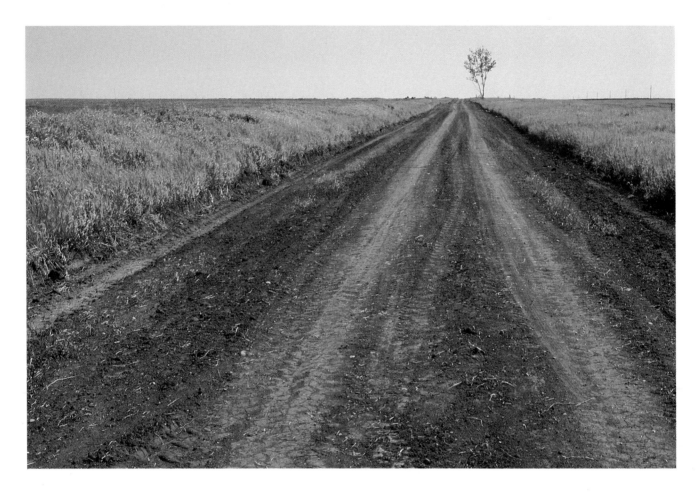

GROWIN' DOWN THE ROAD

K 25
24mm lens
−1 exp for road

On a cloudless summer day the afternoon sun is so high
that shadows appear to shrink in the heat. Tones and colors
are bright but evenly lit, making exposures relatively simple.
After a heavy rain everything flourishes in the hot overhead
sun. Even though a grader has recently widened the ditches,
new alfalfa seed has already sprouted in the fertile soil of this
prairie road.

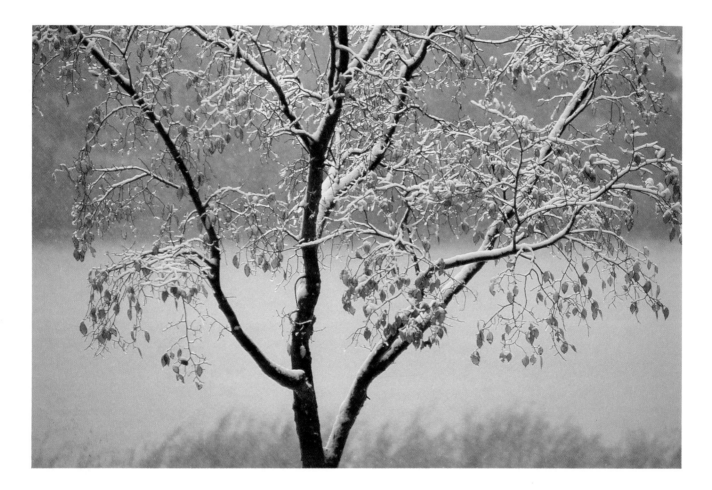

WINTER GREEN

K 64
80-200mm zoom lens at 80mm
normal exp on leaves

Freak blizzards can arrive as early as September on the prairie. Waking up to the new snow is an instant journey to the Magic Kingdom. Even within the first hour of photographing, the snow is melting and blowing off the branches. Why are the things that bring us the most joy so fragile? Is it because these occasions are so fleeting that we find them special? When I find one of life's paradoxes in my viewfinder, such as summer and winter in the same scene, I'm elated with the discovery, yet already mourning its brevity.

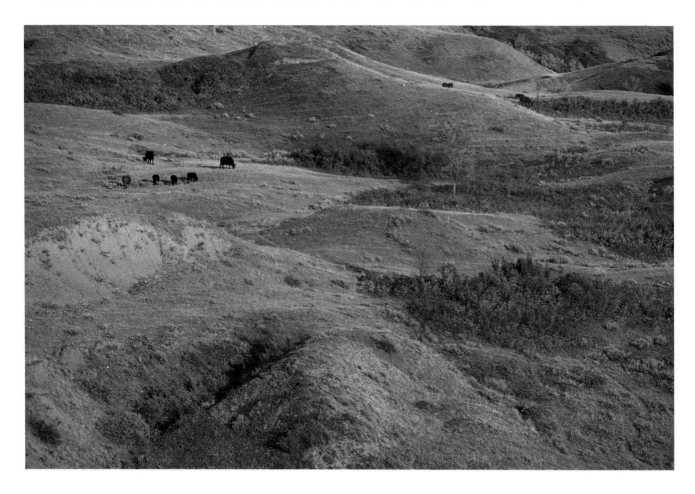

INDIAN SUMMER

K 25
70-210mm zoom at 100mm
—½ exp on scene

After the first snowfall or cold snap the weather can turn warm and calm. The prairie becomes a sanctuary for the soul. Indian summer can last a day or a month, but, however long, the time is precious. It's an interest-free loan from the weatherman, but could be withdrawn at any time. Those are the gifts we enjoy but never take for granted!

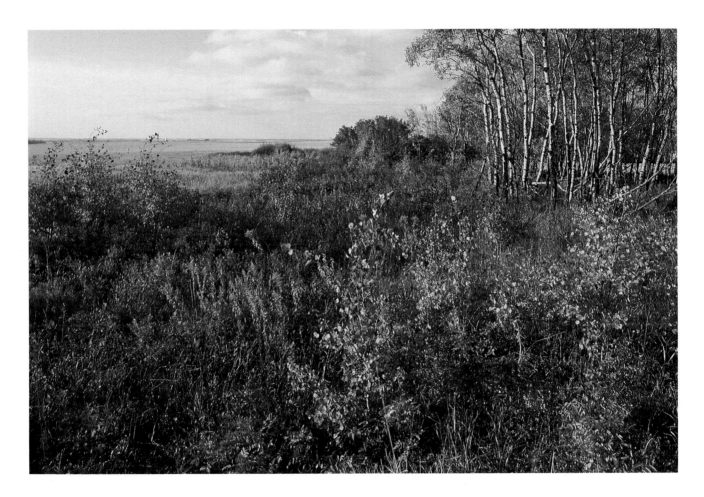

THE POPLAR BLUFF

K 25
24mm lens
—½ exp on bushes

Practically every farm has at least one bluff, a cluster of
trees surrounded by cultivated fields. These areas are the
home of many birds and animals, providing shelter from the
sun and wind, and protection from predators. Bluffs are a part
of the prairie's natural beauty and one of the few places
where the untamed grasslands are preserved.

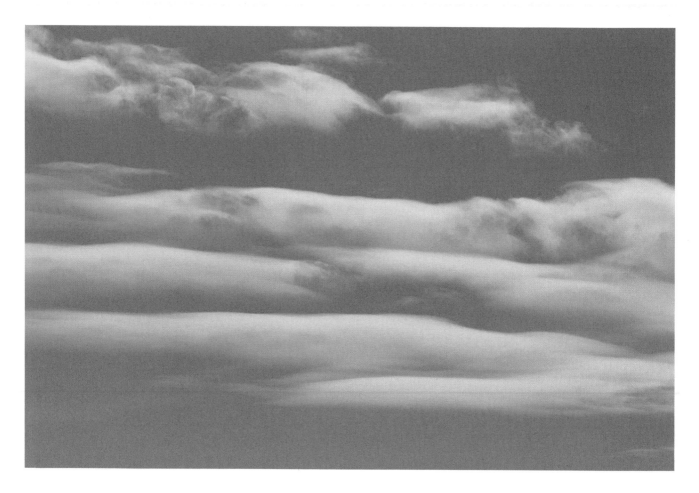

THE BIG BLUE ROOF

Ek 64
500mm mirror lens
+½ exp on the clouds

Afternoon skies can hold your attention indefinitely because they are often on the move. Sometimes it seems as if the sky has a roof, a huge dome that you could touch. On a windy day it buckles and warps. It's probably made of shiny aluminum and reflects the changing colors of sunlight. Ask preschoolers; they are experts on skies. They often include the big blue roof in their paintings.

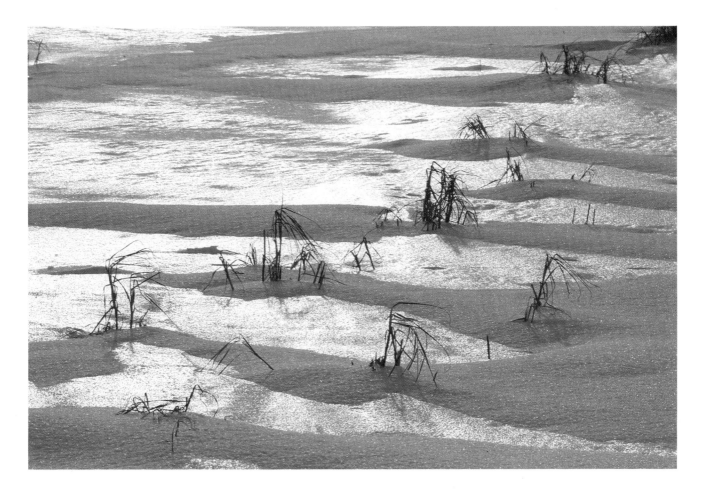

WINTER MARSH

Ek 64
70-210mm zoom at 200mm
normal exp for scene

The winter marsh is an ideal place to explore shapes and patterns. When you photograph sunlight on ice, the angle becomes all-important. By locating the angle of maximum glare, I was able to record the pattern of ice and snow with the greatest tonal contrast. The darker shapes are small drifts of snow on the edge of the marsh. Because the snow is granular like sand it doesn't reflect as much as the smooth ice.

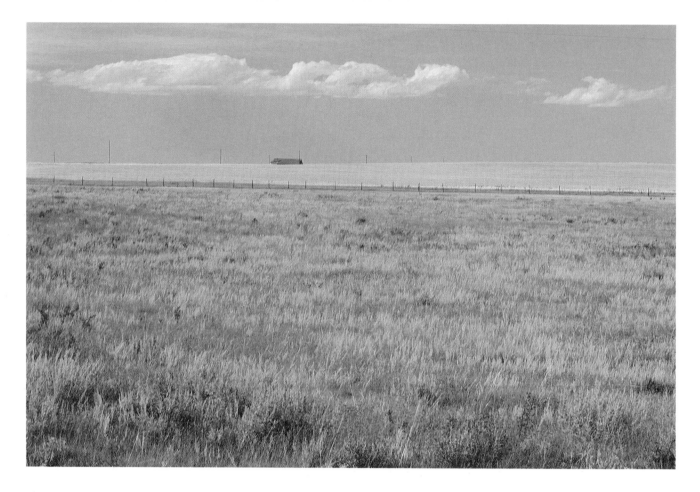

PRAIRIE PASTEL

K 25
55mm lens
normal exp for scene

On afternoons when the clouds roll over the land there is a
continual shifting of light and shadow. In order to get an even
coloration on the field I waited until the entire scene was in
sunlight. Now the delicate balance of greens and blues shows
off to best advantage. Waiting and watching for prairie light is
one of my most enjoyable pastimes.

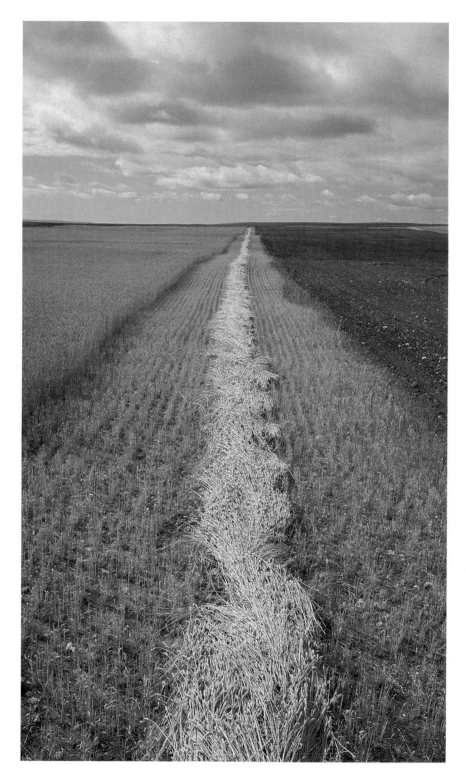

FIRST CUT

K 64
105mm lens
normal exp for field
polarizing filter

When I was young I wondered why the farmers talked about "making the rounds" when their fields were square.

This swath looks like it could run on forever. It doesn't. The swather just turned the far corner after making its first cut. In a short time it will have completed the first round and begun the second.

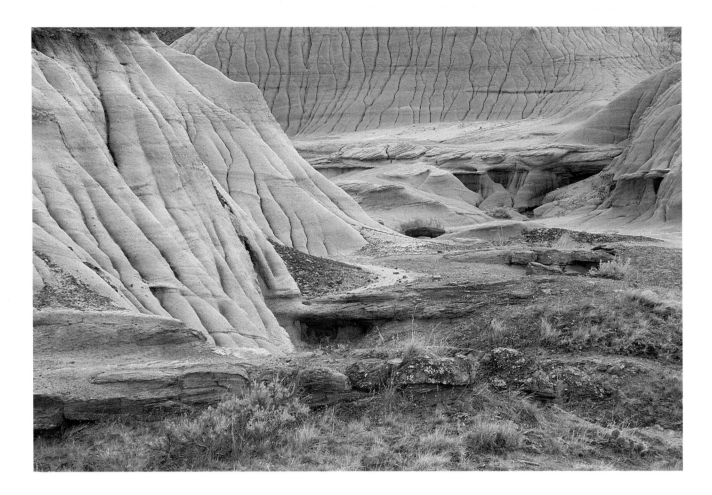

BADLANDSCAPE

K 25
80-200mm zoom at 100mm
normal exp on left side

The badlands are located in several areas throughout the prairies. One of the most dramatic regions of the badlands is Dinosaur Provincial Park near Brooks, Alberta. There are a great variety of formations and an ample network of trails into these areas. The best time to visit is after a heavy rain. Footmarks in the soft limestone have been washed away and the terrain regains the appearance of an age gone by.

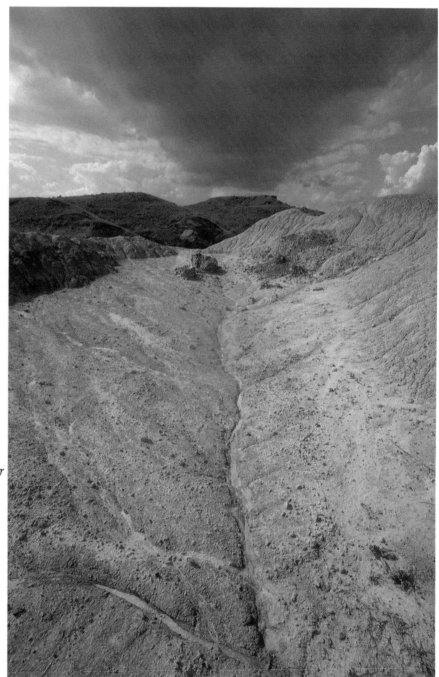

BARREN

K 25
17mm lens
normal exp on rock with polarizing filter

Much of the badlands consists of limestone and because it does not absorb the rain the slopes develop erosion lines which act as a watershed. The limestone also reflects the summer heat turning the whole region into an oven. As the heavy raincloud rolled over, I managed only the one exposure before it blocked the sun from the foreground.

75

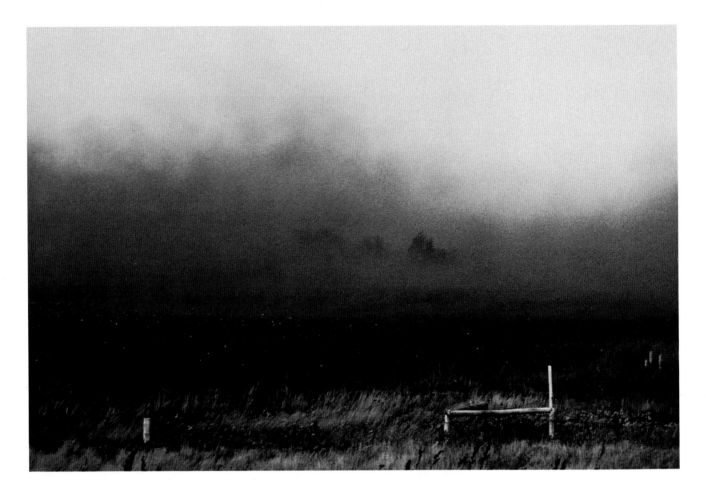

SUMMERFALLOW IN FLIGHT

Ek 64
55mm lens
—½ exp on the dust

Driving in a horrendous wind, I saw this scene, pulled over
to the shoulder, and started to step out. A gust of wind
whipped the door wide open, bending the hinges with its
force. With the wide open door and the front of the van as a
shield from the wind, I braced myself for the exposure. Then I
tied the door to its frame and chugged along to the next town
for repairs.

Was it worth the trouble? I put the picture into a limited
edition of twenty-five prints. It was my first edition to sell
out.

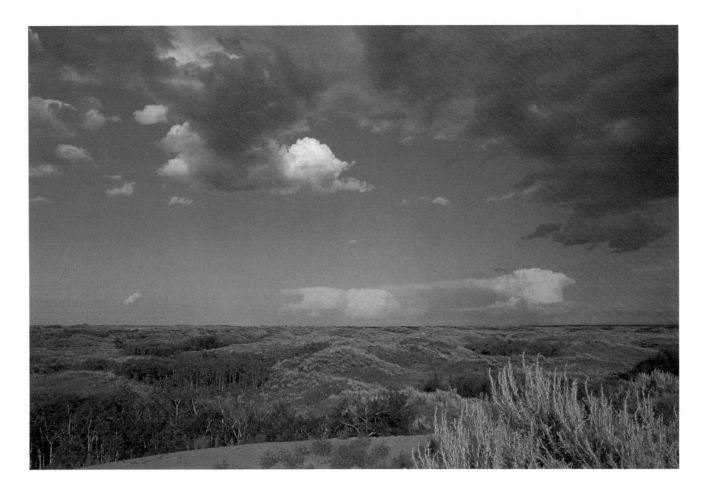

SAGE, SAND, AND SKY

Ek 64
24-48mm zoom at 40mm
−1 exp on blue sky

Some areas of the plains are extremely sandy. Glaciers moving slowly through the country have pulverized the rock into tiny particles. Wind has blown the sand into mounds, and vegetation (sage, juniper, cedar, and poplar) has taken root during the wet seasons. Other areas of the sandhills are active dunes with no vegetation, shifting and blowing on each windy day.

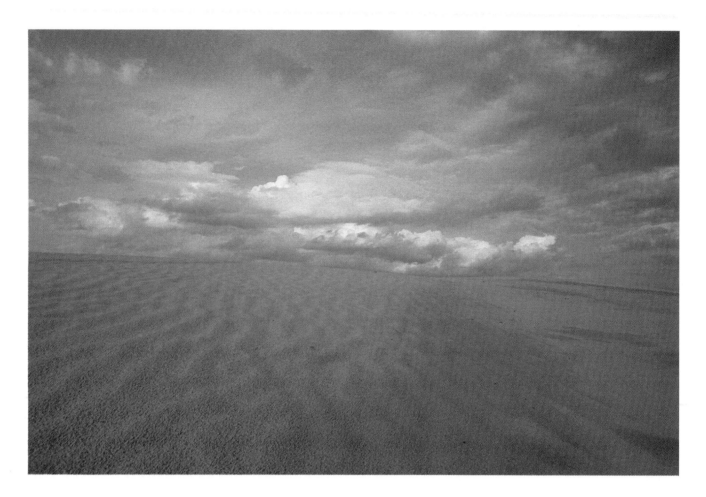

LANDSCAPE OF THE MIND

Ek 64
24mm lens
—½ exp on sand

The Great Sandhills of southern Saskatchewan can carry you away to the uncluttered spaces of your mind. You can walk for hours without seeing a trace of another human being. The sand patterns can lead you to distant horizons, or into the clouds, offering a great escape.

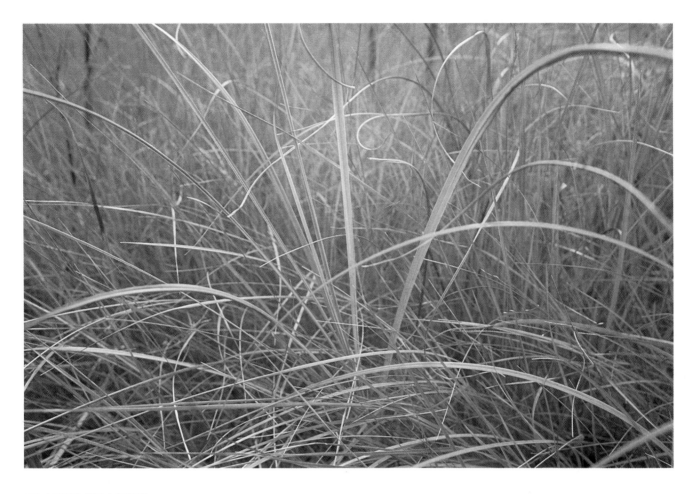

PRAIRIE GRASSES

Ek 64
24mm lens
+½ exp for scene

When the sky is overcast I like to observe the prairie from close-up. What appears bleak and muted from a distance can be rich in color and abound with life. The even tones and absence of harsh shadow make "dull day" photography a joy to pursue. The simple act of isolating a segment of the landscape in the viewfinder can be enough to reveal its essence, or to appreciate its intrinsic worth.

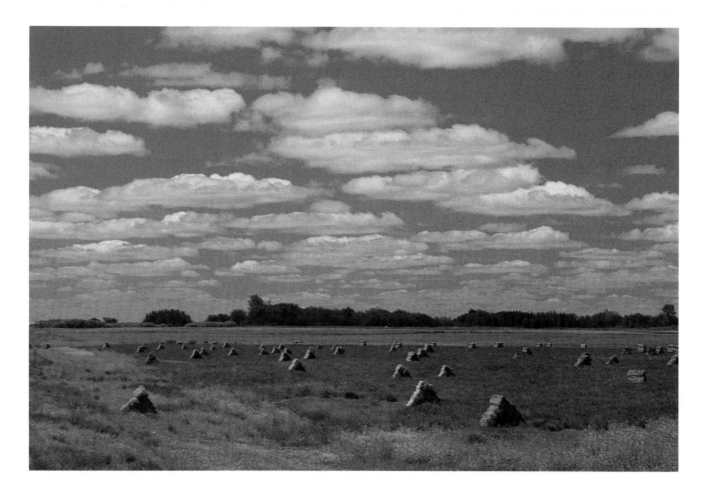

CLOUDS AND BALES

Ek 64
70-210mm zoom at 100mm
−1½ exp on scene
polarizing filter

When I was a boy I traveled with my father who sold farm implements. He was disgusted when he saw hay bales out rotting in the rain. One year he designed a bale stacker that piled the bales in pyramids to shed the rain. His was the first such machine and it stacked twenty-one bales; others of varying sizes followed. As he drove, he kept an eye on the fields. "They own one of our stackers," he would say proudly, pointing at a field of pyramids.

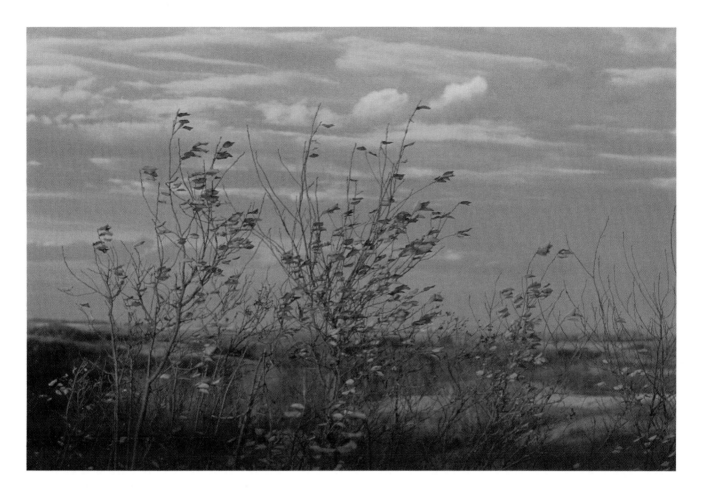

AUTUMN WIND

Ek 64
105mm lens
−½ exp for sky

 Autumn Wind will always remain a personal favorite for me because everything came together at the right time. I first saw the striations in the clouds and hunted for a suitable foreground. The young poplars attracted me because they were on the move like the clouds, but were not bright enough. Lady Luck smiled and the sun came out. Only when the late afternoon sunlight shone on the golden ridges did I discover the repeating horizontals of land and sky.

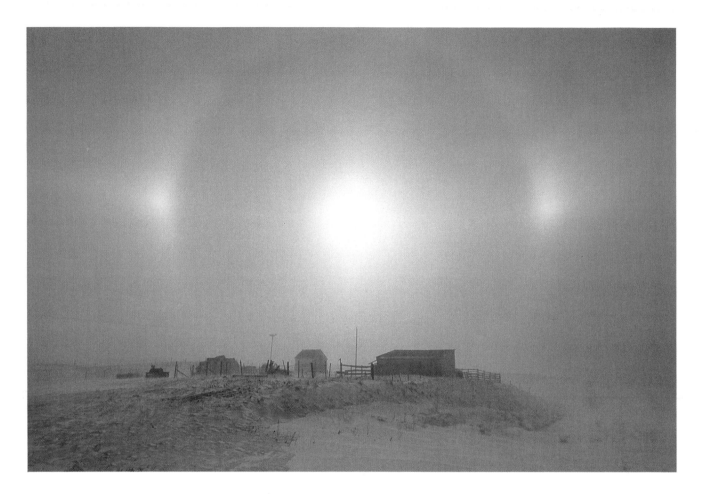

MINUS FORTY

Ek 64
17mm lens
−1 exp for sky without highlights

Both Celsius and Fahrenheit scales agree that minus forty degrees is COLD! When the radio warns motorists off the highway during a February storm I think, "Must look pretty exciting out there," and drive north of town. It is deathly cold, with a brisk north wind. When the sundogs appear I begin looking for an appropriate foreground. I leave my car motor running and head into the storm on foot. The cluster of farm buildings looks cold and desolate, a good complement to the mood of the winter afternoon. Gradually, imperceptibly, the sun descends, and at an undefined moment the day quietly slips into evening.

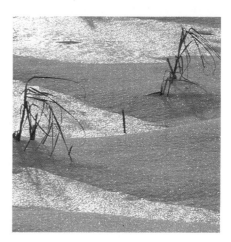

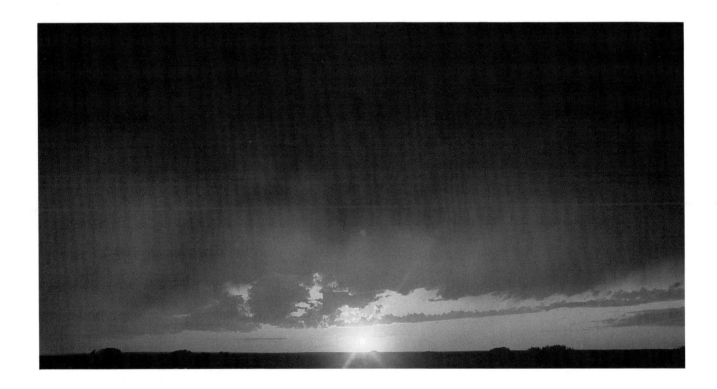

THE GRAND FINALE

The end of a day on the prairie is often spectacular. In the facing photograph the curtain rises again, this time for the grand finale. One of the most enjoyable experiences is to watch the sun come out after a heavy rain or overcast day. Sometimes it will appear briefly several times as though making its curtain calls at the end of the performance. The last few minutes of sunlight are a frantic time to record on film as the splendor of the moment unfolds in virtually every direction.

Several factors account for our famous sunsets. One is their size. They are as big as the sky, often spreading across the entire hemisphere. In late summer the forest fire smoke drifts down from the north, a giant filter that turns the western sky into a sea of opalescent color. There are, in addition, more cloudless days on the prairie than any other region of North America. Thus there is more sunset light.

In winter the sun drops quickly, often without ceremony. But it redeems itself by late spring, the deeply saturated color lingering for hours after the sun tips below the horizon.

The first noticeable shift from the afternoon to evening is marked by the lengthening shadows. As they grow the feeling of texture is enhanced. Any daylight hour can reveal the fabric of the land, but now seeing it is a total sensory experience. Light and shadow sculpt a relief more vivid than the reality of an hour ago. The light is strong, yet gentle, bathing the land in warm, nourishing rays.

The earth responds and conveys its sensuality through color, tone, and texture. Now is the time for the photographer to act and react. The prairie speaks. In a visual, graphic tongue it sings the praises of its finest hour.

As the sun descends, the colors ripen, reaching maturity a few minutes before sundown. The rich golden light is all-encompassing. It soaks into the fields and bounces along the roads. It shimmers off the streams and shines on the ponds. As it floods over the land, a small shaft is deflected and spills through my lens to the awaiting film. Then, as the sun dips behind a cloud, I turn and photograph the western sky. By underexposing a full setting, I can render the sky dark, accented by the black, gold-rimmed cloud shapes.

Occasionally a haze will mute the sun turning it into a crimson ball enclosed in gray. Again I reduce the exposure one setting to produce a darkened sky and a deeply saturated red. When clouds are absent, there is a glow lasting long after sundown. Even if the exposures must be two or three minutes long, I will stay faithfully, recording the dying light. Another day is gently laid to rest and with it comes the birth of a prairie night, even more magical than the sun at its height of glory.

85

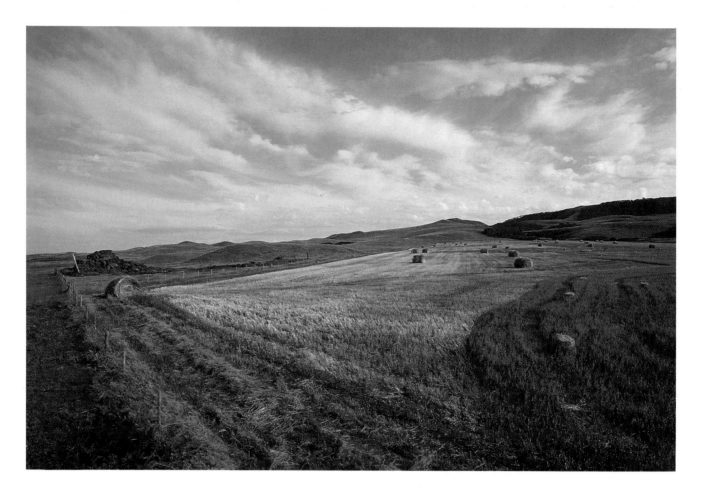

EVENING LIGHT

K 64
17mm lens
−1 exp for field

As the sun drops, its light becomes seductive. Often when I am on my way home for supper, I end up stopping repeatedly for "just one more picture." I love to play with repetition as one of the elements of design. I first look to the sky and then attempt to find a harmonious foreground. The resulting picture often looks as if the clouds are an echo of the land.

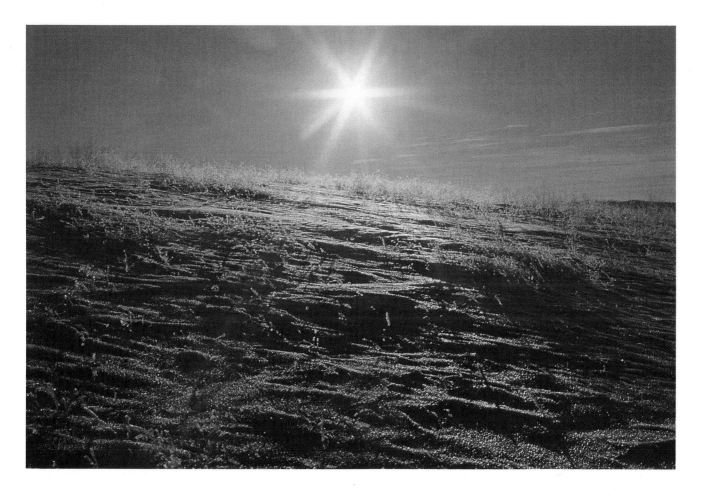

WINTER SUN

Ek 64
50mm lens
—1 exp for snow

Around the shortest day "evening" light arrives by mid-afternoon. Frosty afternoons turn colder while only the light and your desire for exercise prompt you to stay outdoors. Now is when the crusty snow, sculpted by the wind, offers an opportunity to record texture. I turn and face into the sun with my camera. The contrast of light and shadow helps to convey that special winter feeling, a paradoxical blending of warm and cold. How can the most bitter of winter days look so inviting when the mercury shrinks in the thermometer?

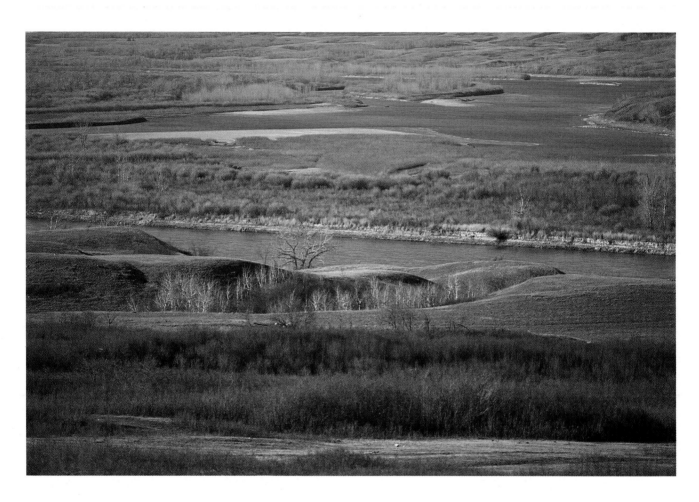

LOREEN'S PLACE

K 25
70-210mm zoom at 100mm
normal exp for red color

The river is a supply route of nutrients for the land, but it also nourishes the soul. There is something whole and good and right about the river. The light is fading but now the warm spring air is an invitation to stay. I sit on a high bank and watch the waning light across the valley. Time contracts and a "now is forever" makes the moment complete.

AT THE SHAWS' CABIN

Ek 64
105mm lens
—3 exp on scene

Black and white poplar trees grow in harmony along prairie lakes and rivers. In late fall, winter, and spring their unadorned shapes offer a glimpse of the woods not seen in the summer. What looked dense and impenetrable during a walk in July now seems strangely vulnerable. The white poplars are the last to relinquish the evening light.

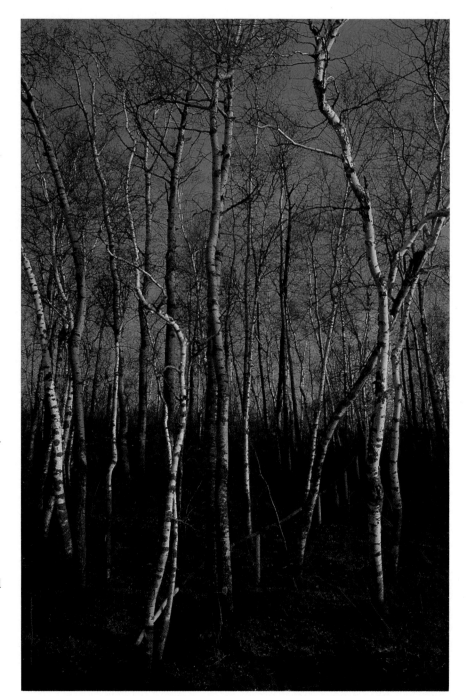

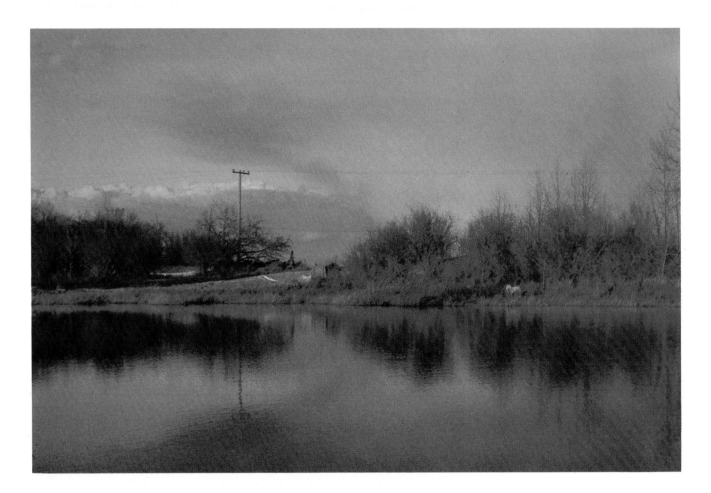

ONCE UPON A LAKE

Ek 64
55mm lens
—1 exp on scene

 I was on the phone to a friend when suddenly I saw the light break through on this scene outside my window. I hung up without explanation and dashed out the door extending the tripod legs as I ran. Eager to join in the excitement, my dog romped around the slough right into my picture. There was no time to call her back, so when she reached the spot halfway along the bushes, I yelled. She stopped short, looked up, and I made this one exposure. She quickly continued her run just as the sun went under. Then I returned to the house and phoned back to explain the abrupt disconnection.

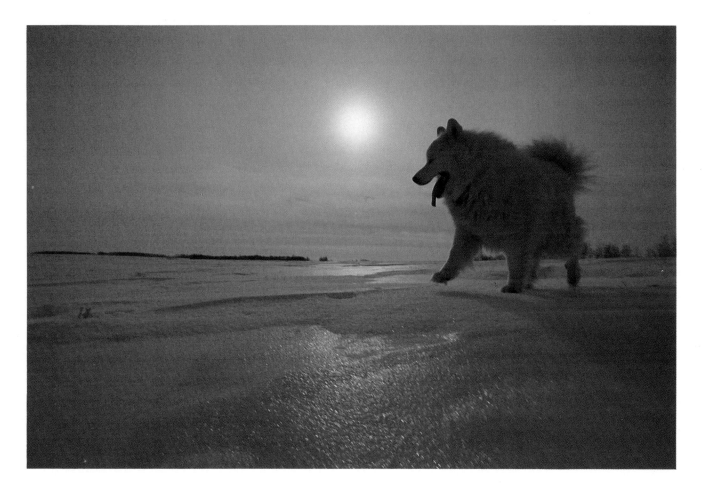

MIDNIGHT SUN

Ek 64
17mm lens
−1 exp left of sun and 85B blue filter

On the chilliest winter days the prairie can look like the arctic tundra. With the advent of nightfall the gray vastness gives way to the deepest of blues. Sasha, my Samoyed, frolics on the crusty snow, unaffected by the severe cold. She could pass for an Eskimo dog on a hunt beneath the midnight sun.

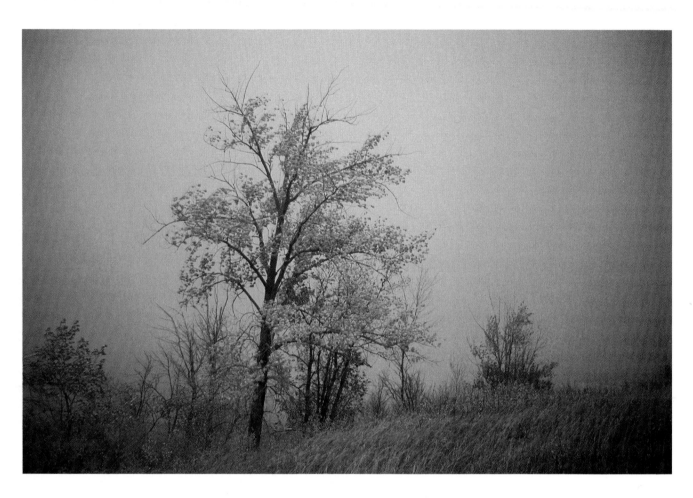

AUTUMN GOLD

Ek 64
70-210mm zoom at 150mm
—½ exp for tree

In 1978 one of the worst dust storms on record swept
through central Saskatchewan. I made this exposure on the
bank of the South Saskatchewan River, but instead of water,
the background is a wall of sand and grit. The autumn color
was so warm and inviting that the photograph appears
tranquil—an ironic twist on the harsh reality of the event.

92

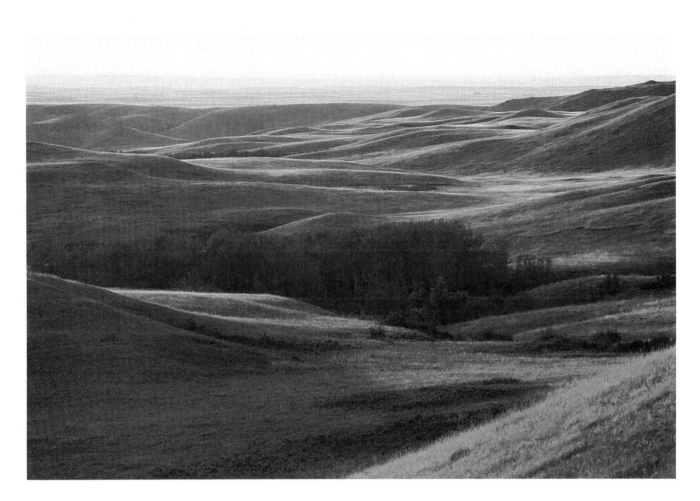

THE HILLS OF HOME

Ek 64
50-250mm zoom at 70mm
—½ exp on scene

The Great Plains are characterized by rolling hills as well
as flat grassland. The evening sunlight rakes across the valley
and highlights the terrain. I like to sit on the crest of the hill
and watch the changing panorama. The play of light and
shadow quickens as the sun descends. There is a golden
moment when the light reaches its warmest glow. Then the
shadows creep over and bury the gold.

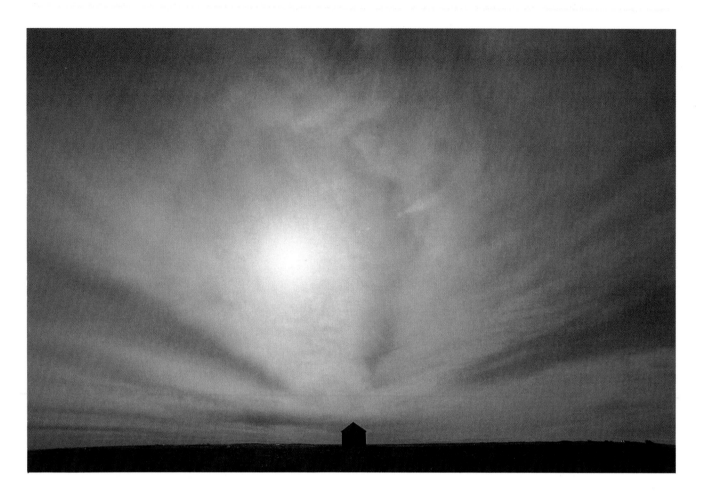

AMBIVALENT SKY

Ek 64
17mm lens
—1½ exp right of dwelling

The theme of this picture depends on how you see the pointed clouds. If your eye follows them in to the building, then the inhabitant is under attack by the elements. The theme becomes "struggle for survival." If, however, you begin with the dwelling and follow the lines outward, the picture has a feeling of man's power, hope, and triumph. When you live on the prairie, you're never quite sure which is the true perspective!

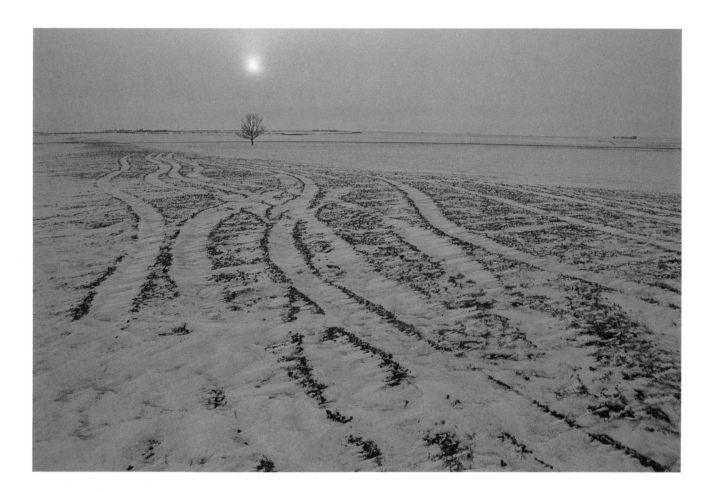

LONE TREE

Ek 64
24-48mm zoom at 24mm
— ¾ exp on scene

Some farming communities have so few trees that anyone
can recognize which tree is in a photograph. Such is the case
here. When a landscape contains only one tree, the sun, and a
field, the effectiveness of the picture requires careful
placement of shapes and lines. I first lined up the sun and
tree, then walked backwards for ten minutes to find my
foreground.

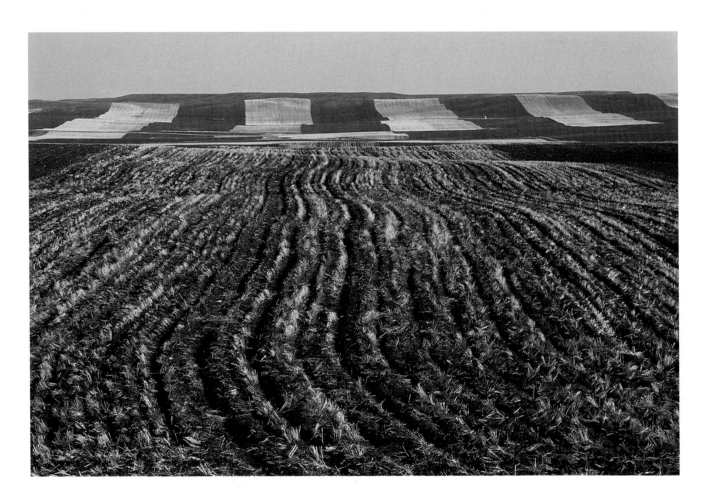

WHEATFIELD GEOMETRY

K 25
70-210mm zoom at 100mm
—1 exp on field

Thanks to modern farming methods, the prairie mosaic offers a rich tapestry of geometric designs. In the foreground, the light casts across the furrows of summerfallow. The distant field is being strip-farmed, the grain planted in long rows with alternate rows left to regenerate.

COTTON CANDY EXPLOSION

Ek 64
24mm lens
−1 exp on midsky

I like to lie on my back and watch the drama on a warm summer evening. One day the candy floss machine exploded throwing fluffs of spun sugar across the theater. Unfortunately, the wind was too strong and none landed! I can't complain. It was an excellent show and the admission, as always, was free!

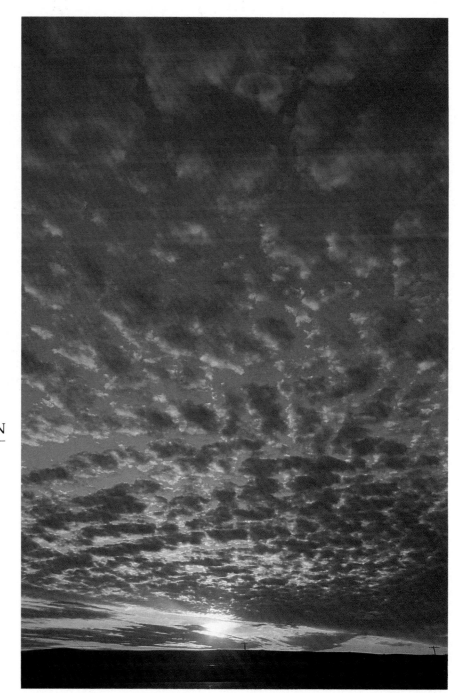

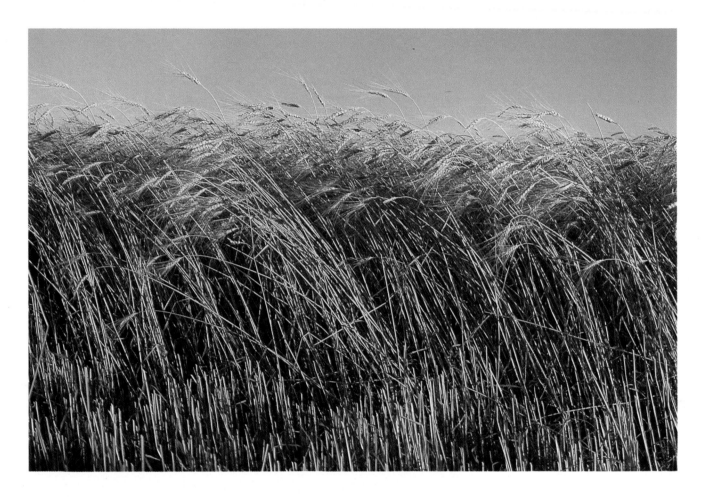

GOLDEN GRAIN

Ek 64
105mm lens
−½ exp on wheat

Sunset light is prairie light at its best! Harvest color takes on a golden sheen that's unbeatable. Some people will look for excuses to be outside at sunset. Real prairie people don't need excuses to be out at this hour! It's the special quality of light that gives them their golden glow!

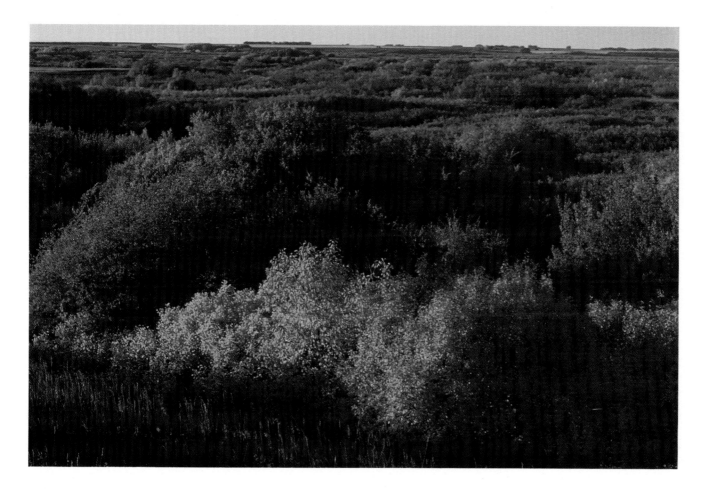

AUTUMN MADNESS

Ek 64
105mm lens
—1 exp on scene

The height of autumn confirms what other seasons only
hint at: the landscape is capable of any color. Add prairie
light which ranges across a complete spectrum of intensity,
temperature, and contrast, and the resulting hues offer the
gamut of human emotion. Autumn sunsets border on the
insane. The palette of riotous color teases the eye like sweet
caramel tempts the palate. You want to shout, wave your
arms, leap for joy, or race for your camera!

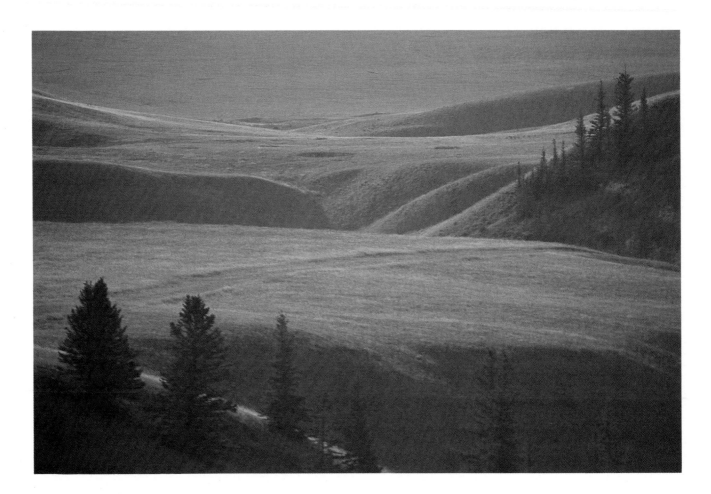

HIGH COUNTRY

Ek 64
500mm lens
—½ exp on center

The light of an autumn evening brings tranquility to the high country. The Cypress Hills region straddling the southern-most boundary of Alberta and Saskatchewan rises to the highest point of land on the Great Plains. Much of the area is now preserved as a park and portrays the untouched majesty of yesteryear. Though the buffalo are gone, elk, moose, and deer flourish in these hills.

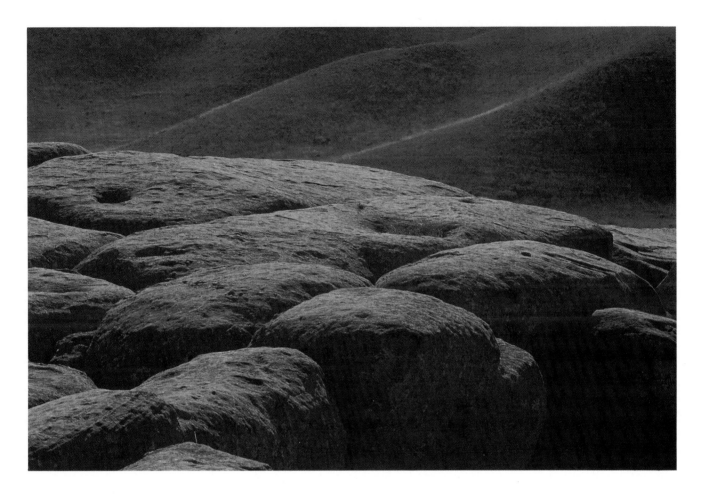

MYSTERY BLOCKS

Ek 64
70-210mm zoom at 210mm
—½ exp on top of rocks

High in the West Block of the Cypress Hills are these strange rocks, carved into regular meter-square blocks about three meters deep. No one knows for certain the origin of the huge cuts. Were they formed by a freak act of nature? Or did a civilization preceding the North American Indian use advanced technology to make the cuts? The answers lie beneath unbroken prairie or have long since vanished.

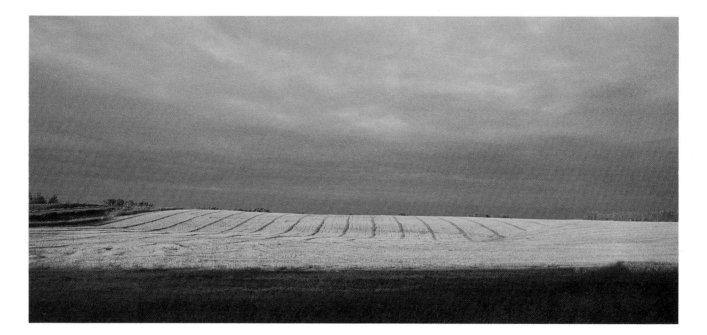

END OF HARVEST

Ek 64
50mm lens
— ¼ exp for sky

When I was a boy, we frequently spent Sundays visiting my cousins on the farm. The visit always ended too soon when Dad would say "Time to go. We should be getting home before dark." Like that of so many farmers his concern was a remnant from the early days when night travel by horse and buggy was often cold and risky. My own consolation was that on the drive home I got to watch the sun setting on the stubble fields.

EVENING RETREAT

K 25
24mm lens
—1½ exp for sky

When you're out on the land, day-to-day problems diminish. Prairie skies are the best cleansing agents to be found. They put things in perspective and set you free. By the time the light has vanished so have your troubles. Reds revitalize, yellows bring cheer, while blue restores peace to a longing heart.

PRAIRIE VOLCANO

Ek 64
17mm lens
—½ exp for clouds

It was one of those lazy midsummer evenings. The air was warm and windless; a smokey gray haze hung on the western horizon. Then I found this knoll with a crater-like notch carved in the top. I quickly lined up the sun to give my volcano fire and used my widest lens to provide scale and show the "smoke."

104

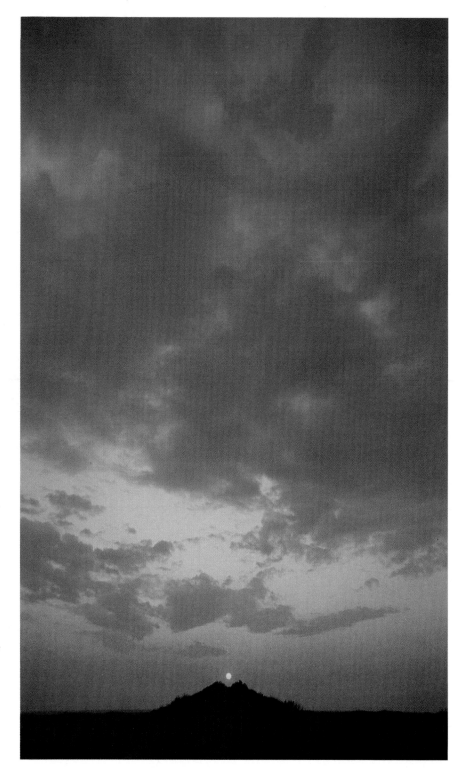

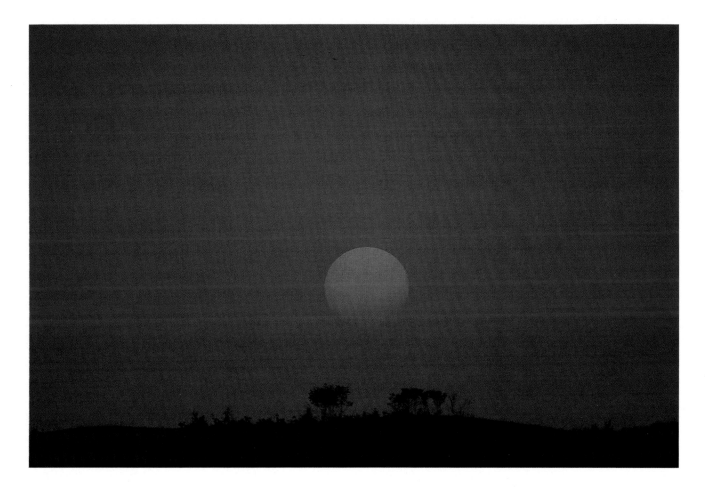

HARVEST MOON

K 25
500mm mirror lens
—1½ exp for sky

As I finished "activating the volcano," the sun slipped into the haze, its color turning to a deep crimson. I instinctively changed to my longest lens to increase the relative size of the sun and looked for a new foreground. Not far away was a grove of small trees. Within a minute, I was recording the big, red sun, which looked more like a harvest moon. It's amazing what secrets the prairie reveals when you give free rein to your imagination!

SPACE VOYAGE

Ek 64
35mm lens
−1 exp on sky

Sometimes in midwinter the windswept fields fill their hollows with snow but bare their ridges. The patterns suggest to me a flight through outer space, traveling at the speed of light. Maybe it's our furrowed fields that account for the numerous UFO sightings on the Prairies!

FARM TRAILS

Ek 64
70-210mm zoom at 70mm
normal exp for sky

Evening light has turned this stubble field to gold. As the sun descends, you can watch your shadow stretch to a hundred times your height. These trails are the supply routes for seed grain, fertilizer, and agents for weed control. Then at harvest, they will be the first to bear the weight of another bumper crop. From truck to bin, to semi-trailer, elevator, railway hopper, to terminal and ship, the grain will become bread on the tables of the world.

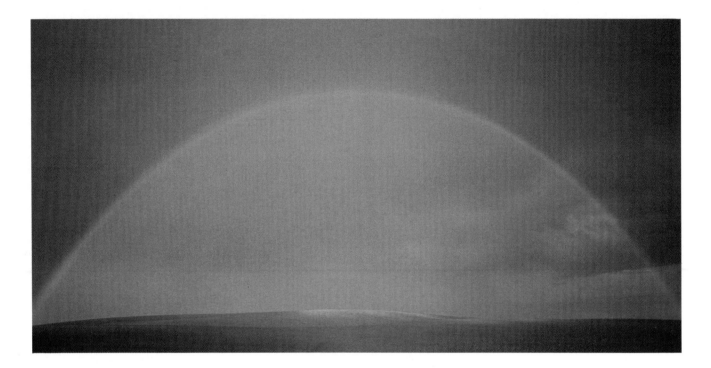

RAINBOW IN THE EAST

Ek 64
17mm lens
−1 exp for sky

A full rainbow on the prairie is always a time of special importance. A rainstorm can arrive too late, delay harvest indefinitely, or come as an answer to prayer. Whether a curse or a godsend, the rain ends with its classic display of color, the proverbial sign of hope. Because our welfare is so closely tied to the land, we watch for the familiar bands of color and welcome all the hope we can get.

PRAIRIE GOLD

Ek 64
70-210mm zoom at 210mm
—½ exp for gold

Gold is not necessarily at the end of a prairie rainbow; sometimes it's in the middle! After making the picture on the preceding page, I zoomed into the middle of the rainbow and focused on the field. That's not a grain crop or a field of flowers; it's the fallow earth receiving the most bounteous prairie light.

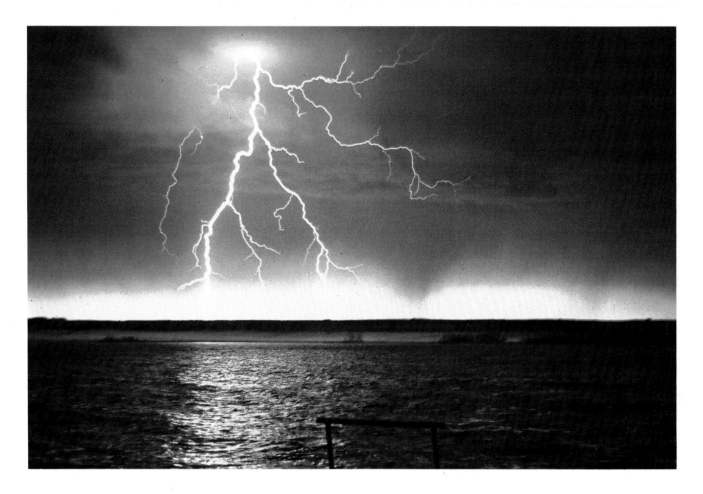

LIGHTNING OVER WAKAW

Ek 64
55mm lens
−1 exp for water

One evening I stood beside a lake watching the gray glow on the far shore. The mauve sky in the north reflected in the rough water and mingled with the orange sunset light. As I was setting up to record the scene on film the sky suddenly filled with fork lightning. I impulsively hit the shutter but was sure I hadn't been quick enough to capture the bolt. When the film was processed I was overjoyed to find the magic moment preserved.

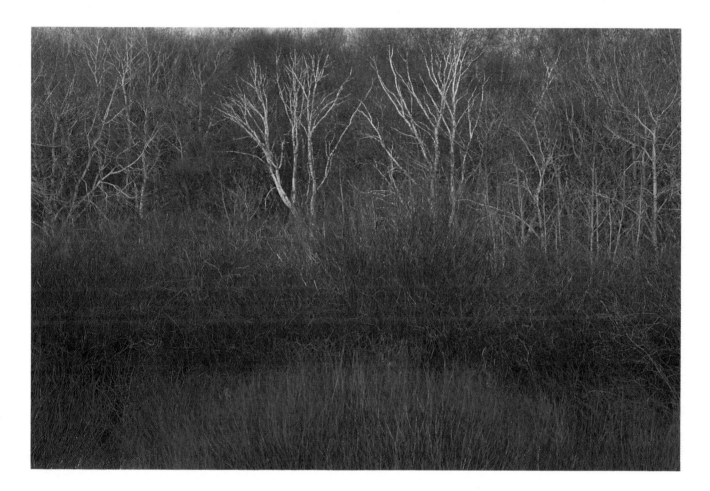

POPLAR BONES

K 25
55mm lens
—½ exp for scene

Even after one or two snowfalls December can arrive
without its usual cover of white. The winter air is crisp but
the land retains its look of autumn. Now lakeshores and
bluffs display their ruddy reds while poplars shamelessly bare
their limbs to the cold. The late day sun lingers but a
moment, then offers a last warm caress, and the willows
respond with a passion that only evening can awaken.

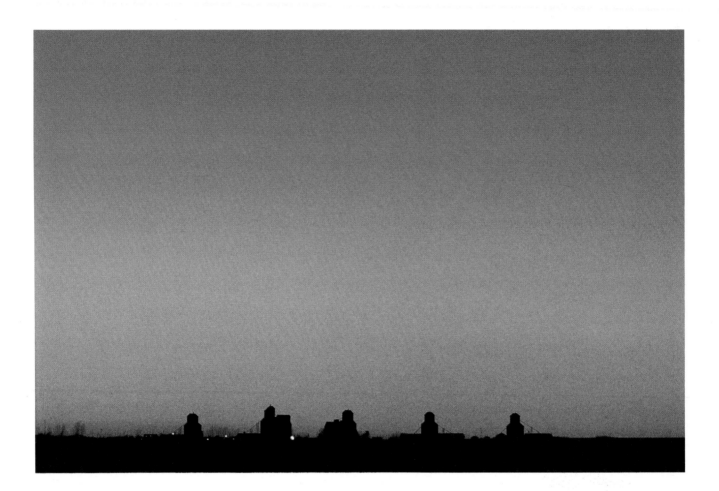

FADING LIGHT

Ek 64
70-210mm zoom at 100mm
—½ exp for sky

On a June evening the twilight lingers for hours after sunset. During the longest days the northern sky never completely darkens as the deep violet glow slides quietly into dawn.

Daylight or dusk, the distinctive shape of a prairie town is created by its grain elevators, announcing its identity even before its name can be read.

THE LAST LIGHT

K 25
55mm macro lens with three extension tubes
normal exp on center

 By the time the sun reaches the western rim, its power has been spent. It often appears extra large but muted as it sinks into the dust of a day's labor on the fields. To exaggerate the size of the dying sun, I used three extension tubes with a macro lens focused close-up on the tiny leaves. The sun grew proportionately large in the frame because it was severely out of focus, but still maintained some sharpness since it was distinctly brighter than the hazy atmosphere around it.

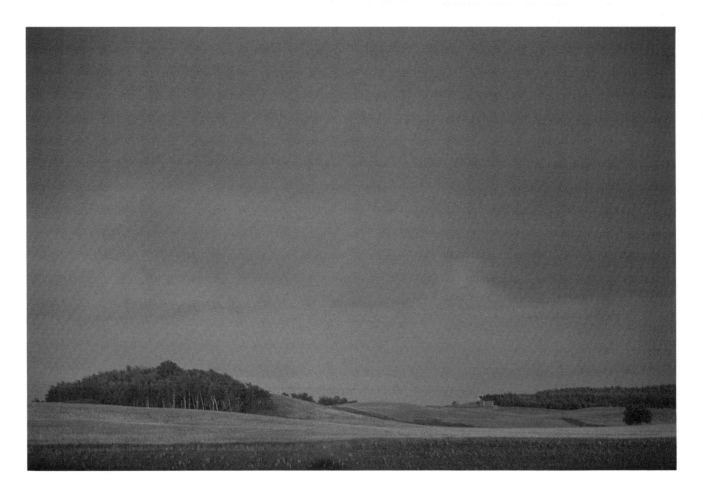

ONCE UPON A TIME

Ek 64
70-210mm zoom at 210mm
—½ exp on sky

Once upon a time, the air was clean and fresh. Each evening the whole town would turn out to marvel at the sunset light. Gradually, the town grew to become a city and more industries located there. The people became very busy keeping up with the modern pace and didn't notice the colors were becoming more muted in the smog. Besides, they had color television, electronic games, and discos to provide them with all the glamor they wanted.

And they lived "happily ever after."

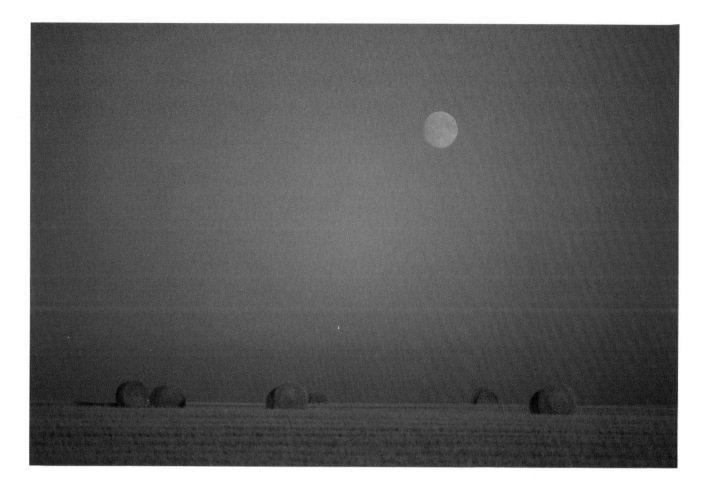

MOON AND BALES

Ek 64
70-210mm zoom at 210mm
— ¾ exp for sky

I look forward to the days when the moon rises at sunset. Sometimes I will scout locations in advance as I did with these round bales to prepare for the grand occasion. The moon only rises at sunset one night a month (one or two days before full moon) and the bales are only on the field for a short time each year. Consequently, there are only about five minutes each year when this photograph is possible.

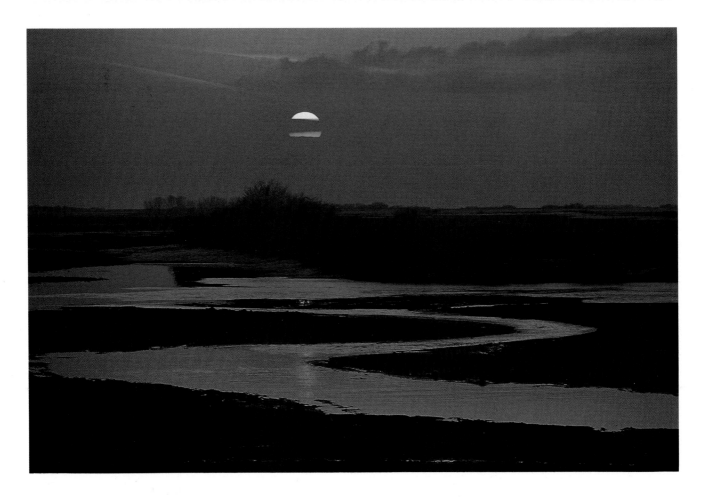

SPRING THAW

K 25
50-250mm zoom at 250mm
—½ exp for water

 If I was frowny, as a child, my mother would play
"smiley-face." She would slowly wipe her hand over my face
from chin to forehead and the frown would magically turn to
a smile. Here a thin cloud passes across the face of the sun
and like magic, the sun changes its mood.

 The ribbon of water on the field is the result of a quick
116 spring thaw.

THE AFTERGLOW

Ek 64
50-250 zoom at 180mm
normal exp for scene
exp time: 90 sec.

Look south and east twenty minutes after sundown.
Though the brightness of the land appears to wane, its color
reflects the spirit of the sky. I have found that with camera on
tripod, I can record the nuances of dreamy color with long
shutter speeds. Greens become golden, grays turn to pink,
and browns take on a tinge of violet, the rolling hills dressed
in their moodiest light!

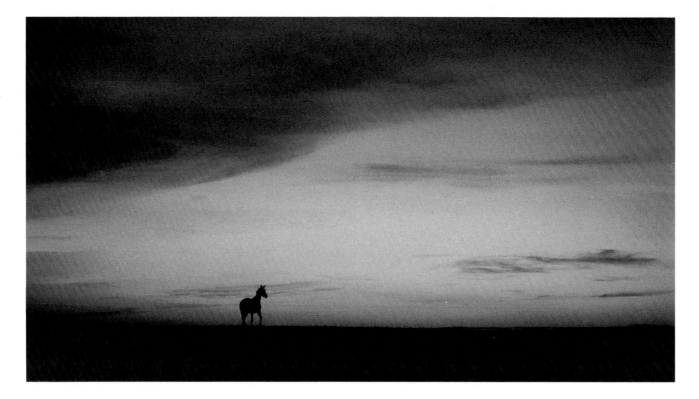

ESCAPING THE STORM

Ek 64
50mm lens
—½ exp on lower sky

As I was photographing the sunset, this horse saw me and trotted over for a closer look. I quickly set my camera to a fast shutter speed and made several exposures of him silhouetted against the sky. As he approached his stark shape became lost against the dark earth. How often I wish animals would repeat their actions for me. Like the horse, the opportunity to capture the motion is fleeting. By including a lot of dark sky I have made the horse look as if he is escaping rather than approaching.

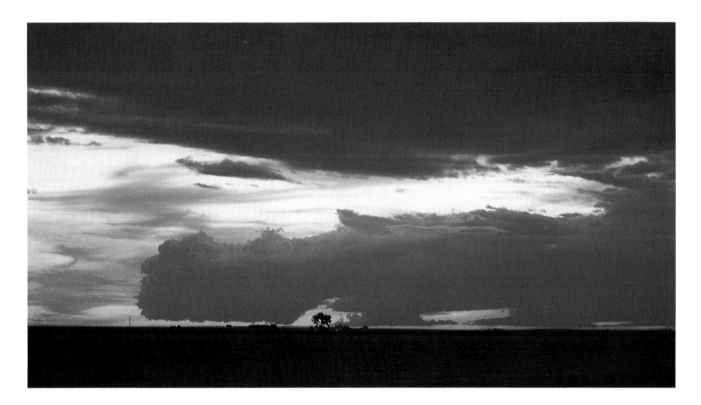

SALAMANDER SUNSET

K 25
70-210mm zoom at 150mm
normal exp for sky at left

When I first encountered this stiff-legged salamander, the tree was to the distant right. Time was of the essence. I struggled through high wet grass, tripod held above my head, and worked my way to a railway track. As I ran, the salamander slowly crawled into place stretching his neck over the tree — and I caught him.

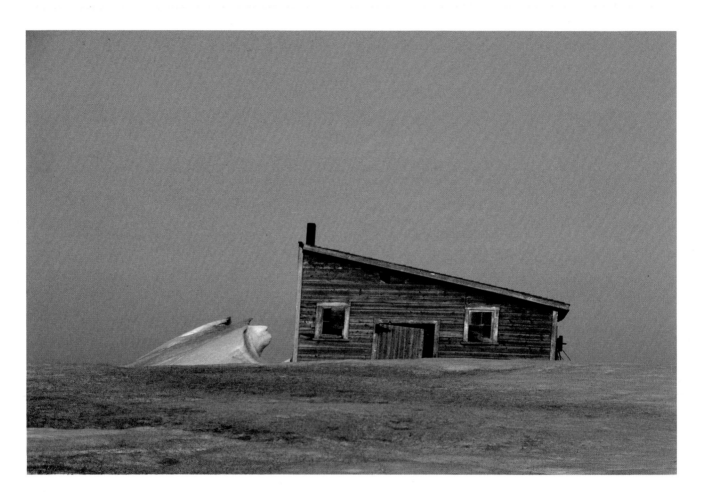

THE ODD COUPLE

K 25
70-210mm zoom at 210mm
−1½ exp for sky

During the thirty or forty minutes following sunset, the
eastern sky melts into the soft pastels of evening, often
turning briefly to a delicate mauve. Then, as the light fades, a
misty blue spreads upward, replacing the warmer hues. As
the tones deepen, they announce the advent of night, but a
snowdrift, protected by the shed, is the last to relinquish the
daylight.

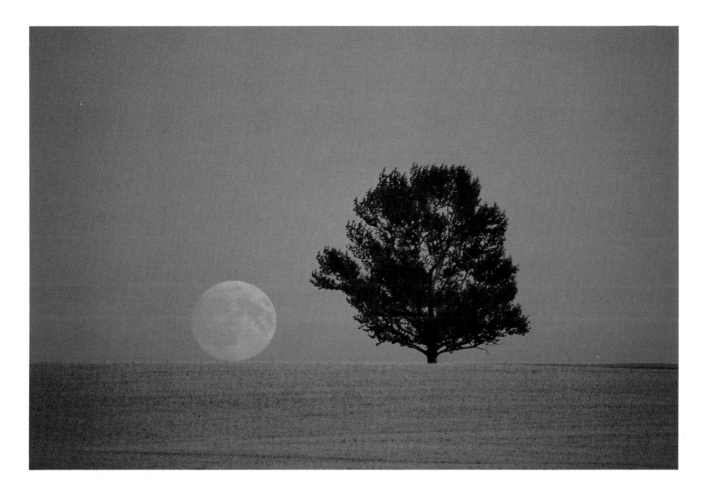

DOWN TO EARTH

K 25
500mm mirror lens
normal exp

I have a strong attraction to the full moon. Once, when I had stopped to photograph a single tree silhouetted against the pale eastern sky, I noticed a tiny sliver of light on the horizon. The full moon was rising right into my picture! I used a long lens half a kilometer from the tree to reduce the size of the tree compared to the moon.

121

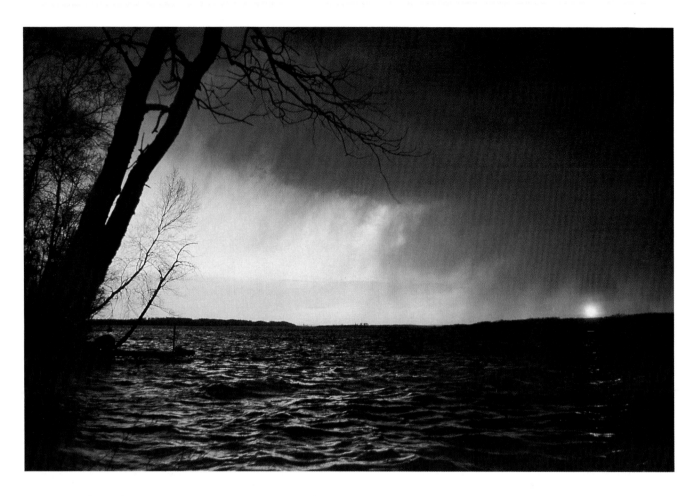

WAKAW SUNSET

Ek 64
35mm lens
+1 exp for light sky

After thunderstorms, as the dark clouds roll across the sky,
I see day and night in the same scene. By reducing the
amount of exposure, I rendered the clouds almost black,
further enhancing the contrast of tones. When night and day
appear together, they become opposing forces, each
competing for dominance. I placed the shrinking sun far to
the right, as if it were retreating from the impending
darkness. The trees, shrouded in blackness, have already
conceded to the force of night.

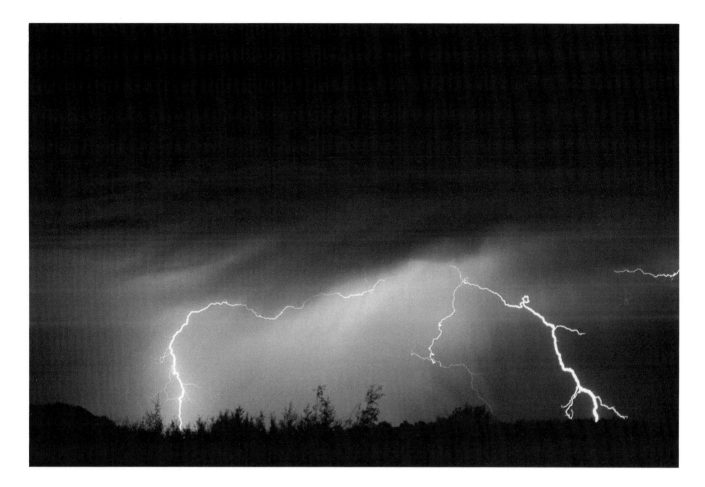

NIGHT STORM

Ek 64
50mm lens
exp for 15 sec.

It's a special treat to stay up late in the summer and witness the lightning storms. You can gauge the distance the storm is away by counting the seconds between the lightning bolt and the crack of thunder. It takes the sound about three seconds to travel one kilometer. Because lightning can be seen from a great distance, the delay can be as long as ten seconds or more. If lightning and thunder strike together, look out!

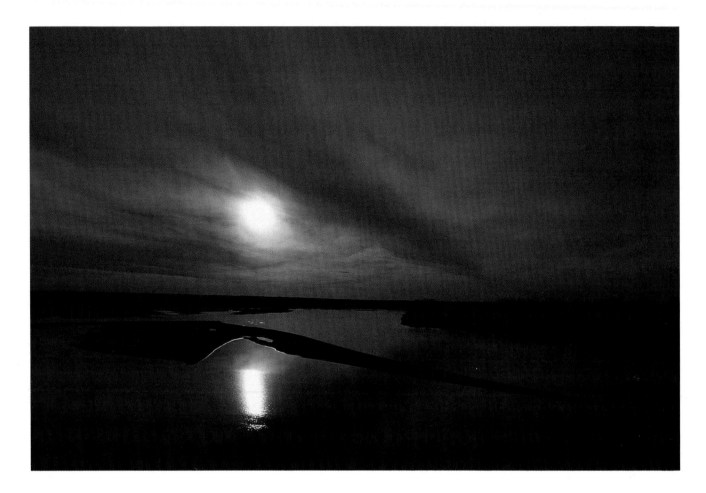

SANDBAR ON THE SASKATCHEWAN

K 25
24mm lens
−2 exp for sky at night

Night skies can turn as black as ink, if there are no town lights to reflect off the clouds. Just as the morning sun can push away the darkness, so too can a black sky engulf the sun in its heavy cloak. Like *Wakaw Sunset* this scene impressed me with its duel of light and dark forces. I waited until the spearlike cloud blew into position over the sun before making the exposure.

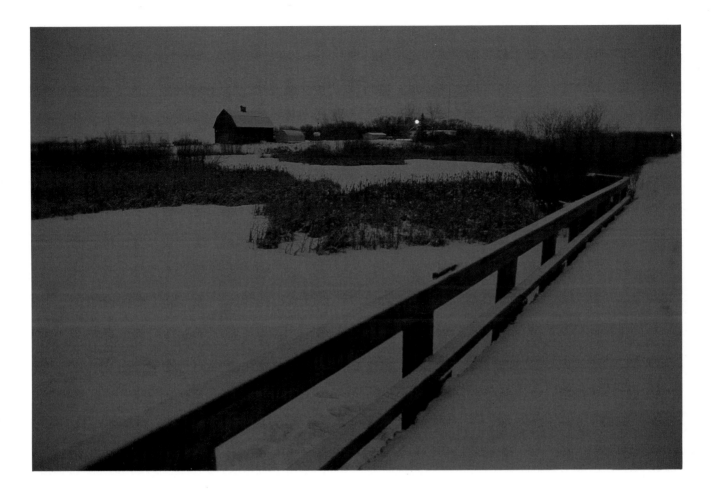

ALMOST HOME

Ek 64
50mm lens
—1½ exp for scene

An empty road on a winter night can wrap you in loneliness. Feet and hands grow numb; cold pierces to the bone. The silence is broken only by your boots on the hard-packed snow and your own labored breathing. Tonight the walk seems endless. Then a tiny golden light pricks through the blanket of night. The distant yardlight is as warm and welcome as a blazing hearth. Almost home!

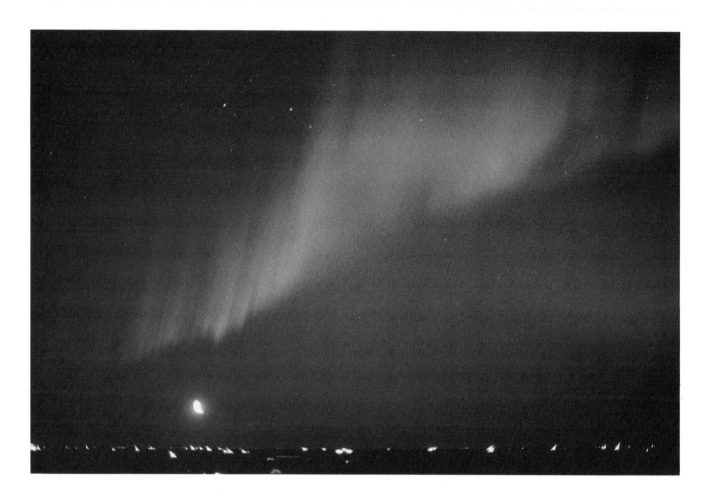

MOONRISE AND NORTHERN LIGHTS

Ek 400
f1.4 50mm lens at f1.4
exp for 4 sec.

The Aurora Borealis is the late night show of the prairie, arching and carving its way across a fluid expanse. No other natural phenomenon will draw people out to gaze in awe like the northern lights. They dance and prance, shimmer and shake, then sweep across the midnight sky in a final gesture of triumph. Then as suddenly they vanish and the night sky fades to silence.